ARTIST'S PROJECTS YOU CAN PAINT

10 Landscape Styles in Mixed Media

by Robert Jennings

international
artist

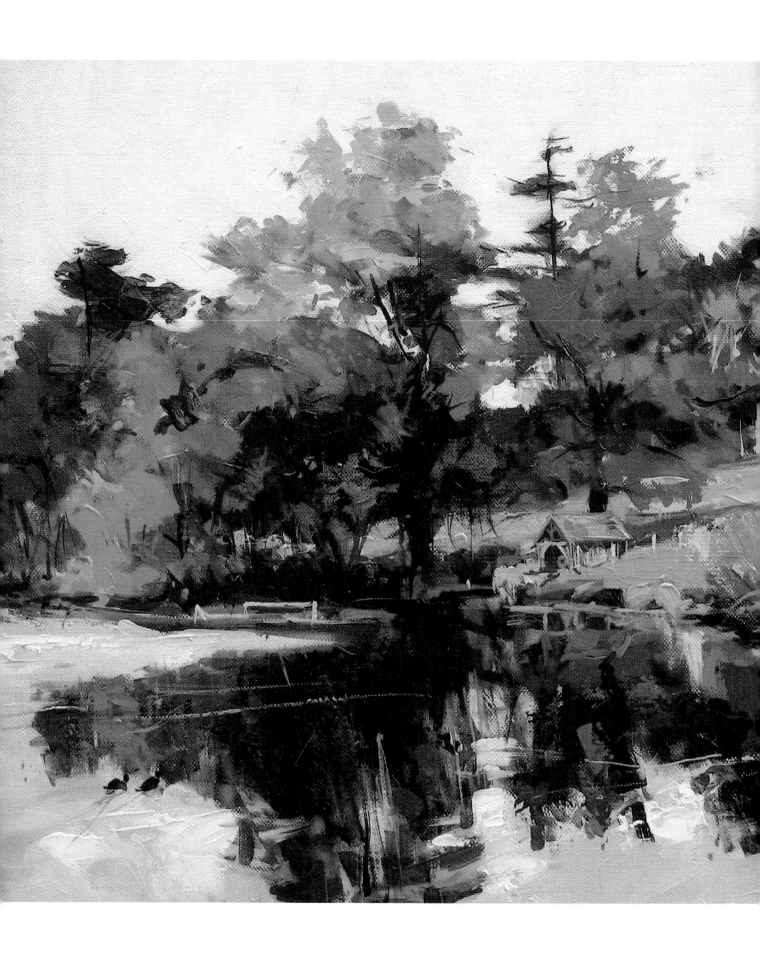

Autumn Color and Reflections, oil, 16 x 22" (41 x 56cm)

ARTIST'S PROJECTS YOU CAN PAINT

10 Landscape Styles in Mixed Media

by Robert Jennings

international
artist

International Artist Publishing, Inc
2775 Old Highway 40
P.O. Box 1450
Verdi, Nevada 89439

Website: www.internationalartist.com

Edited by Terri Dodd
Designed by Vincent Miller
Typeset by G. Reid Helms and Cara Herald

ISBN 1-929834-55-1

Printed in Hong Kong
First printed in hardcover 2005
09 08 07 06 05 6 5 4 3 2 1

Distributed to the trade and art markets
in North America by:
North Light Books,
an imprint of F&W Publications, Inc
4700 East Galbraith Road
Cincinnati, OH 45236
(800) 289-0963

Dedication

This book is dedicated to my wife,
Jean, and to artist friends who have
encouraged my interest in painting
and creative work throughout a
fascinating life.

Acknowledgments

To my friends at International Artist
Publishing Inc., who have provided
this opportunity to write a book
featuring my particular approaches
to painting, and to Terri Dodd in
particular.

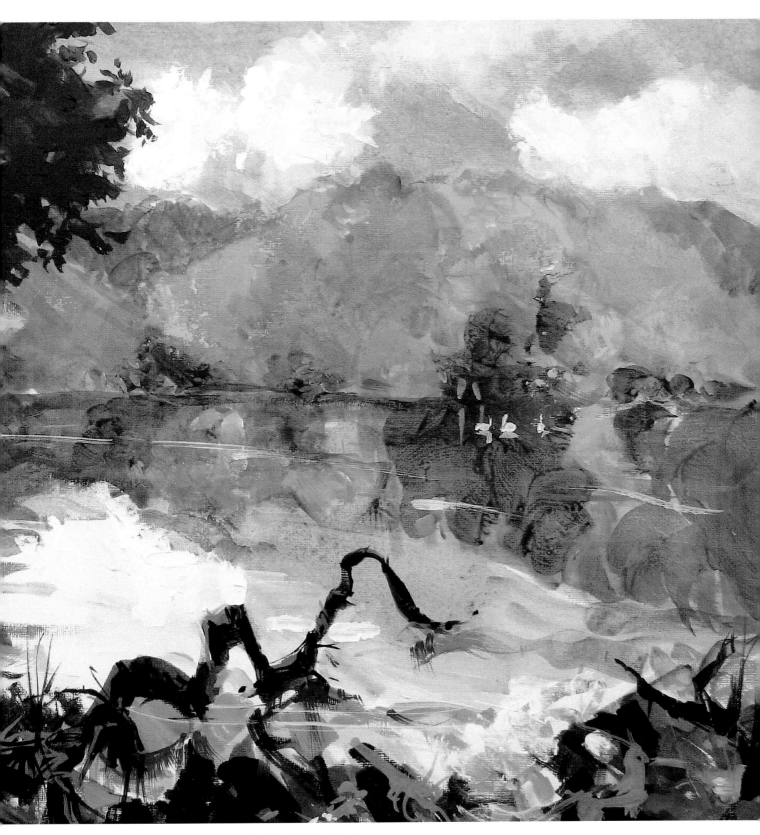

Frenchman's Creek, Helford River, Cornwall, acrylic, 15 x 19" (38 x 48cm)

CONTENTS

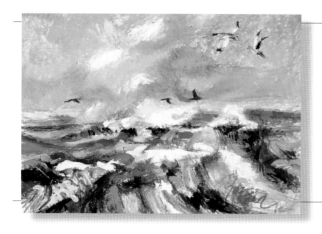

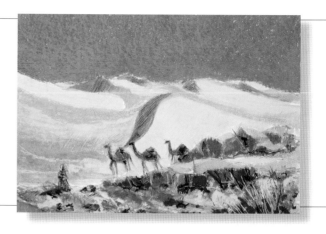

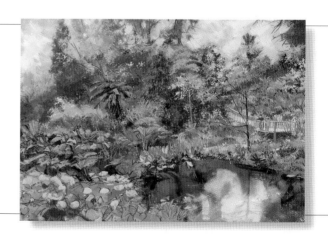

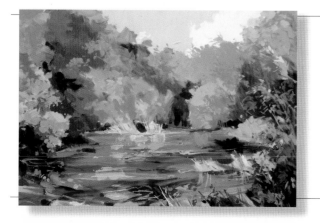

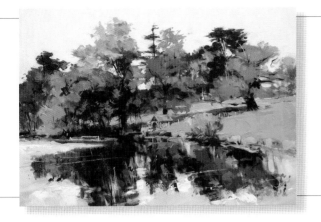

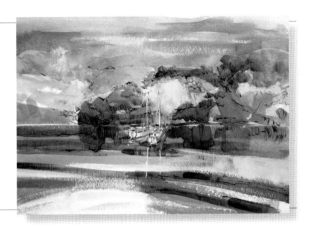

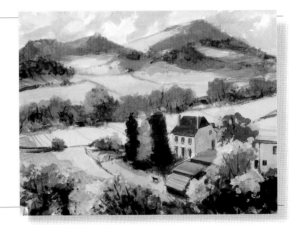

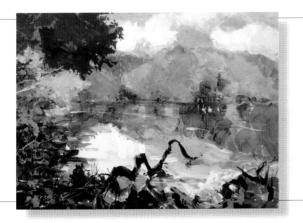

INTRODUCTION

The purpose of showing my own wide variety of work is to suggest that there are plenty of creative avenues available to you. Once you try them, you may find some mediums to be more fruitful than others. Alternatively, one approach may lead to another. It's all about finding your personal style.

My different styles really stem from the characteristics of the different mediums. Others stem from the discovery that I'm not very good at some mediums and have greater success with others. It would be useful, at least, for you to have an idea of what each does to see which mediums suit you.

At school I, like everyone else, painted in watercolor. From the school's point of view, it was cheaper and less messy than other mediums.

Watercolor is very difficult to use properly, that is, to apply beautiful and immaculate washes that look brilliant and can be strengthened or reduced at will. It can involve wet-on-wet techniques, full wet washes, or dry brush. It is a transparent medium, subtle and suggestive of moody atmospheric effects. At the same time it offers power and drama, with contrasting opportunities for detail and flamboyance.

When working with watercolor, I found that I preferred to establish a color image first and then draw the detail later with India ink, usually with a pen but on rare occasions with a brush. In theory my drawing was better than my watercolor. I had the option of painting in rather stilted watercolor and then more brash, bold pen and wash. Since I was working on quick sketches for effect, frequently on site, this style suited my requirements. I must say, however, that if one is trying to impress by the skill of one's penmanship, then the drawing needs to be pretty good.

An extension of watercolor was what used to be called poster color at school, but that we now call designer color or gouache. This flat water-based medium allows you to overlay light colors on dark, something that is difficult in ordinary watercolor.

I also adopted gouache for my pen-and-wash work, where I tend to use white, or colors tinted with white, for opaque, light-colored highlights. It occurred to me that gouache as a total medium could provide benefits all round. It dries quite quickly, it is opaque, it loves rough paper, and it particularly lends itself to dry brush work. Gouache is useful for very detailed subject matter because its ability to be painted over means you won't ruin the work if the first attempt is a failure. It is also possible the use the medium freely. Sounds like a justification for poor work, but that is not so! Even though it is still possible to make a hash of it, gouache is very artist-friendly.

Because I like drawing, I occasionally use oil pastels. It is not an easy medium to get to grips with in a free drawing style because it tends to stick and is not easy to apply fluently.

My oil pastels are quite large. To help cover the ground I use a bold color statement first, rather as in my watercolors. Some of my most successful works in oil pastel have been underpainted with quick-drying alkyd oils first. In this way I can begin drawing quite soon over a colored, rough painting that shows enough of my eventual intentions. As the work progresses, and to increase the drama, strength and color, I alternate oil and oil pastel as often as it takes.

Ever since I was a young man I have loved the idea of painting in oils. Apart from everything else, you look like an artist! There have been times when I have thrown the whole kit and caboodle in the bin out of sheer frustration. But I go back to it. Recently I have enjoyed painting the beautiful landscapes that surround me here in the beautiful English countryside of Devon.

Oil painting requires some knowledge of the medium and its limitations. Like every other paint application, it depends on what you see and how successful you can distil the scene to manageable proportions — quite apart from your painting skills. I apply much the same technique as with every other medium. I try to establish the color look of the picture and then work with the medium to achieve an acceptable match. Whilst many oil paintings take months to finish (and even longer to dry), I prefer to consider it another sketching medium, and for this reason I use alkyd oils. With bold application of thick paint, you feel you are making progress.

The most recent addition to my repertoire of mediums is acrylics. At the point of writing this book, I have done very little with acrylics though I have certainly invested in the materials. But I like the idea for a number of reasons. It is water-based and need not be too messy. It lends itself, in theory at least, to my styles in both oil and gouache painting. It also allows me to use the medium opaquely in order to continue with the detail all the way through.

My most successful acrylic painting so far, apart from sketching in a life group, has been a landscape with flying geese. It looks exactly like my gouache paintings of similar subjects. Watch this space, though; it is early days.

Over and above all this is drawing; drawing everything is routine to me and should be for you as well. I tend to draw with color from the start. The object of the exercise is to draw what you see and to understand the difference by which light affects what you think the subject should look like. It is also a vehicle for learning styles — not for their own sake, but to expand one's versatility.

During the course of this book I shall be demonstrating styles in a these mediums and will try to cover salient points to show how I tackle them. I hope what I have to say will encourage you to try a new medium or two, without panic and with a sense of adventure. Trying something new can be much more absorbing and, in the end, more satisfying when you succeed. So keep an open mind. I paint things now, sometimes fairly successfully, that I would never have attempted in the past. As they say, you never stop learning.

And that's why I wrote this book: to share with you the important things I've learned about painting in a variety of mediums.

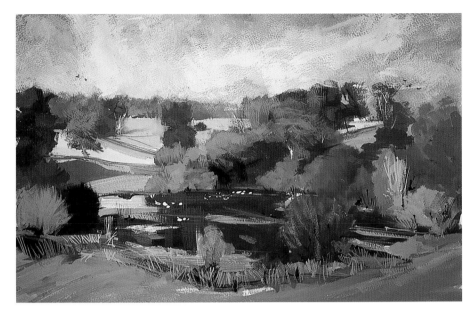

Peaceful Lake, Devon, England, Gouache, 13½ x 18" (34 x 46cm)

A motto to paint by

If you find yourself halfway through a potential masterpiece with no clear idea of what to do next, don't give up. If you had an idea in the beginning, then it is still there and just needs restating. If the work is taking over, go with the flow. You will be surprised how much one can learn from apparently insurmountable problems.

Whatever you do, work towards your goal. That is the way to learn.

How to use this book

In stage painting it is necessary to plan each step and to make points in sequence so that they are understood by the reader.

Before one even begins a painting, however, one must first choose a subject and a manner of presenting it. After this, if you are like me, you select your medium — which is not necessarily the same as a 'method of presenting it' — and consider the finished size and degree of spontaneity or detail.

This book features work set out in step-by-step, or stage painting form, not so much as a formula but to show how a picture might develop. If you find yourself halfway through a potential masterpiece with no clear idea of what to do next, don't give up. If you had an idea initially then it is still there and just needs restating. If the work is taking over, go with the flow. You will be surprised how much one can learn from apparently insurmountable problems.

Whatever you do, work towards your goal. That is the way to learn.

Materials

- There is a price differential between 'artist' and 'student' quality paints, but the cheaper the product the less pure the pigment contained within it. A similar measure applies to brushes, which are available in pure sable, very good synthetics and cheaper hair. Bear in mind that a good brush will hold paint better, will hold its point, will not shed hairs and with careful treatment, will last longer.
- My choice of colors is based on that of a highly experienced artist who lives in Dartmoor. His brief listed included New Gamboge Yellow, Venetian Red, Raw Sienna, and a dark blue. From these one should be able mix any color one needs. I must admit, I add a few to this as the subject demands, for instance, Alizarin Crimson and Olive Green. The point about all this is: don't attempt to use too many colors.

There are many brands of paper on the market. The main considerations are weight and texture. A lightweight paper — even a substantial one — requires stretching, meaning you must wet it and tape it to a board to prevent it buckling. The standard surface watercolor paper finishes are Rough, Not (not pressed), and HP (hot-pressed or smooth). My personal preference is for heavy handmade paper, sometimes tinted, which I use for both watercolor and gouache. You'll see my recommendations for the support (painting surface) at the beginning of each project.

Choose your medium

To begin you must first choose a subject and a manner of presenting it. After this, if you are like me, you select which medium to use. Then you will consider the finished size, the painting's format (landscape or portrait shape) and next you consider degree of spontaneity or the amount of detail you will include.

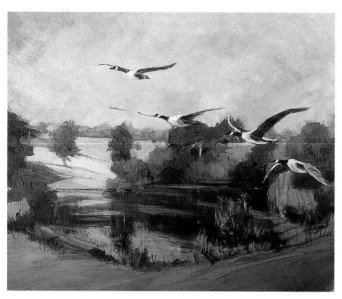

Canada Geese at Shobrooke Park, Devon, England, 13½ x 18" (34 x 46cm)

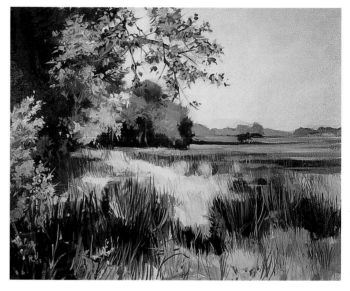

Sunlight on Marsh Field, Devon, England, oil, 16 x 20" (41 x 51cm)

Acrylic painting

I will tell you that I am not too familiar with this medium beyond having decided that it offers quite an opportunity for two elements of my overall style. These are the potential opacity of the paint (rather like oil or gouache), and the chance it offers to draw.

Acrylics are water-based and very quick drying. The colors available are fewer than for watercolor, but some brands offer the same colors in their acrylic range as their oil paint range.

Acrylics are available in two basic consistencies, thick for impasto work and thin for glazing, but the range of special effects mediums is extensive. These cover gloss and matt mediums, gels for thinking and bulking up, flow enhancers and retarders. This is, of course, an oversimplification.

The most important factor about acrylics is their convenience — they are not too messy; quick drying; and easy to overpaint without obscuring the underlying paint. The problems arise from trying to get the work done before your brush dries solid. You have to follow the rules. You can paint on many supports provided they are clean, non-oily and dust-free.

The finish of an acrylic painting is optional. I have painted acrylics that look like gouache. Others can look like oil paintings. In general, I think, the colors tend to be brighter. But you be the judge. Have a go.

Oil painting

A complete description of this medium is long and complicated, but for our purposes a short note may suffice.

Pigments are ground into a drying oil to a consistency that provides ease of handling and the distinctive appearance of the paint.

I currently use alkyd oils. They are bound with a synthetic resin, which dries much faster. Alkyds and are reported not to darken with age.

Oils can be painted on stretched canvas or canvas board, wood, or any substantial and prepared surface. The range of colors is basic and I tend to use the same colors as I would for gouache. Oils can be applied in their original thick, straight-from-the-tube form, with a brush or painting knife, or they can be diluted with turpentine or one of many painting mediums to permit finer detail and glazes.

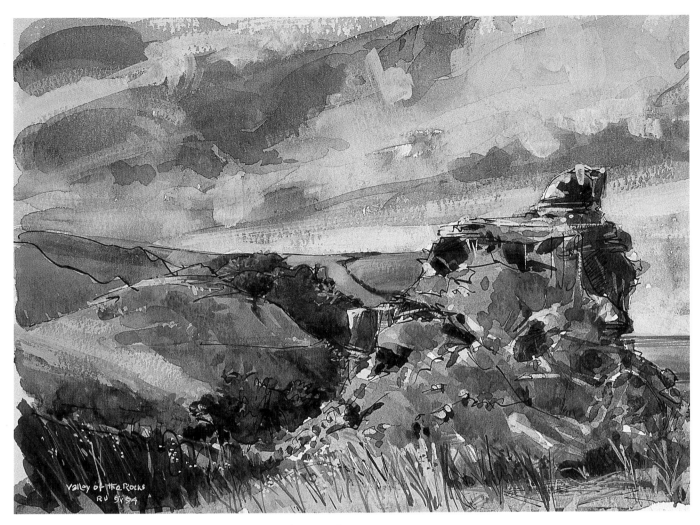

Valley of the Rocks, Devon, England, pen and wash, 7 x 19½" (18 x 24cm)

Pen and watercolor wash

The idea here is to begin with a watercolor wash and then overlay ink.

Watercolor is a transparent medium. One can paint a second or third wash over the first to amend the tone and intensity but one has to be careful not to let the work become muddy. Watercolors can be used in a very wet form (wet-on-wet) or delicately, area by area. They provide an opportunity to sketch or to work up highly finished paintings. It is not an easy medium to master — if one ever does. My solution is to sketch quite freely (I use it mostly outdoors) and strengthen the quick effect with ink.

The most important consideration when embarking on experiments with watercolour wash and ink is to make sure you buy waterproof ink! The last thing you want is to add crucial lines to your watercolor underpainting only to watch the ink spread and ruin your work. Visit your art materials store and ask to see the inks that are waterproof, and contain pigment, not dye.

To apply ink you can use drafting pens, nib pens, quills, sticks and rigger brushes. Inks also come in a range of colors, but I find the black and brown ones suit my style.

With a watercolor pad, a few colors and my pen and ink I can achieve the sense of a place. The results can either stand alone or serve as preliminary sketches for major works in other mediums back in my studio.

When it comes to materials, it is really a matter of being spoiled for choice. Certainly, experimenting with different mediums could help you find your own personal style. I think one has to look at the work of others and to decide which way you want to go. I spent a long time trying to find a good course and was advised just to get on with it. There's a lot to be said for that mindset: view and study, yes; but get on with it.

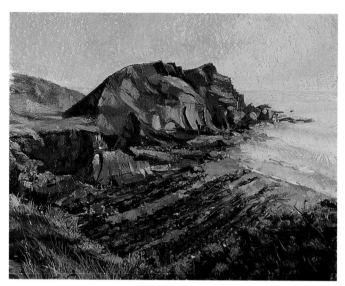
Rocky Coastline at Hartland, oil pastel, Devon, England

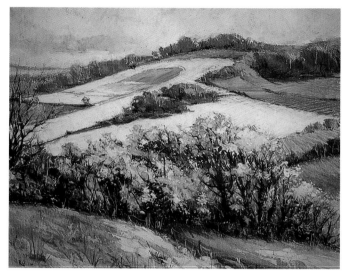
Posbury Clump, oil pastel, 23 x 26" (51 x 66 cm)
A fairly large work to show the geological formation of volcanic sill, with faults running down the hillside to the city of Exeter, Devon.

Oil pastel

I am not sure how I began with this challenging medium. It is not like soft pastels, which can be dusted on and off; oil pastels are more like crayons. The sticks are made from pigments, hydrocarbon waxes, and animal fats.

Some people recommend using turpentine to liquefy them to a degree, which seems to defeat the thickness they offer!

My own method is to use oil paint as a basic color and then build up the oil pastel image, alternating oil and oil pastel until I deem the work finished. I suppose this is because I often paint quite large oil pastel paintings 30" wide.

I apply oil pastels as I would use a pencil, drawing with the point. On rare occasions I tear off the wrapper and use the long flat length. On rough paper, this rides over the textured ridges, sometimes creating quite magical effects.

Drawing can play a major part in oil pastel work and this may be what attracts me to it. You have to work at it. As the job gets more strenuous — and you limber up — so the pastel becomes softer and deposits more color, which I like.

The two projects in this book are quite different. The seascape on page 14 was enhanced at a late stage with painting knife-applied oil paint. The desert scene on page 22 was scratched back to break up the color. Many artists mix pastel colors by cross-hatching and super-imposition. Oil pastel has endless permutations.

Gouache

Gouache is also known as designer color, because commercial artists have been using it for decades. These paints provide a uniform covering, so they are especially good if you want to achieve flat colors. Gouache was also used by the Pre-Raphaelites to produce magnificent and highly detailed work.

Gouache colors are similar to watercolor and I tend to use the same colors but in a wider range. Because they are opaque colors, referred to as body colors because they add substance, they make it simpler to paint an area in the correct shade than to overlay watercolor washes. Brushes and other materials are generally the same as those required for watercolor, except that you need to change the water more frequently.

As well as adding lines in ink to my watercolor paintings, I began to highlight certain areas in white. In time it occurred to me that what I was using was a gouache technique: applications of water-based opaque color that could also become watercolor washes if diluted sufficiently. Gradually I developed a style that could be either free or detailed, or a bit of each.

My gouache work is both free and detailed. It is fairly hard work unless you are able to capture a fleeting image in a few brushstrokes.

The great benefit of using gouache is one's ability to go on with the painting, to overcome difficult bits. Gouache is something to try and, whilst I would not give up my sketchy watercolors, I feel I have really improved.

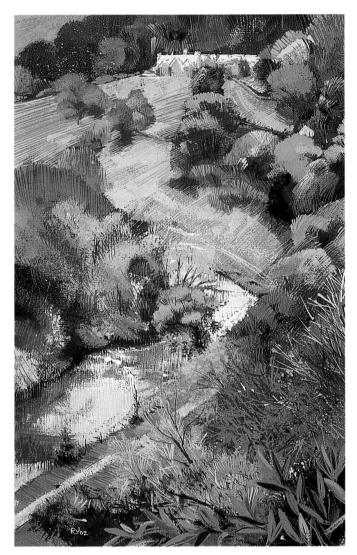
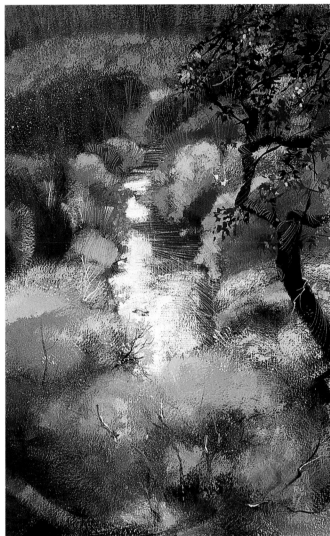

Endsleigh, gouache without yellow bush, **14 x 9" (36 x 23cm)** at left, and gouache with yellow bush, **14 x 9" (36 x 23cm)**. Endsleigh was once the country estate of the Duke of Bedford. These pictures show the view from the Alpine Cottage, built to show the River Tamar looking north to the house and looking downstream to the south.

Copyright warning!

Artist Robert Jennings has generously supplied some exceptional paintings for you to copy. He knows that it is only through practice that skill is built. However, when you copy these paintings, please respect the artist's copyright. Other than for educational purposes, it is against the law to make copies of another artist's work and pass it off as your own. So, by all means show your finished versions of the projects to your family and friends, but please do not sign them as your own, exhibit them, or attempt to sell them as your own work.

PROJECT 1 OIL and OIL PASTEL: *WILD WATER*

Combining oil paint and oil pastels to suggest action not detail

During a winter visit to Cornwall my wife and I stayed in a cottage overlooking offshore rocks. There was always plenty of activity out there. And depending on the tide and wind, the view was constantly changing. There was always spray, a great ingredient for a seascape! With a bit of hazy sun to brighten up the elements, a few birds and a grumpy sky, the scene was set anytime I wanted to paint. The inspiration for this project was action!

I have used this subject to demonstrate oil pastels because it shows that one need not paint in great detail. The medium and your own approach to a subject can leave you with complete freedom of action. Even this demo is exciting!

The challenges
- To depict an active scene with minimal detail.
- To stop fiddling and finish.

What you'll learn
- How to convey action.
- How to paint with minimal detail.

Techniques you'll use
- Using textured acrylic paper.
- Sketching with graphite.
- Strengthening colors.

Before you begin, read the entire project through so you know what's going to happen in each stage.

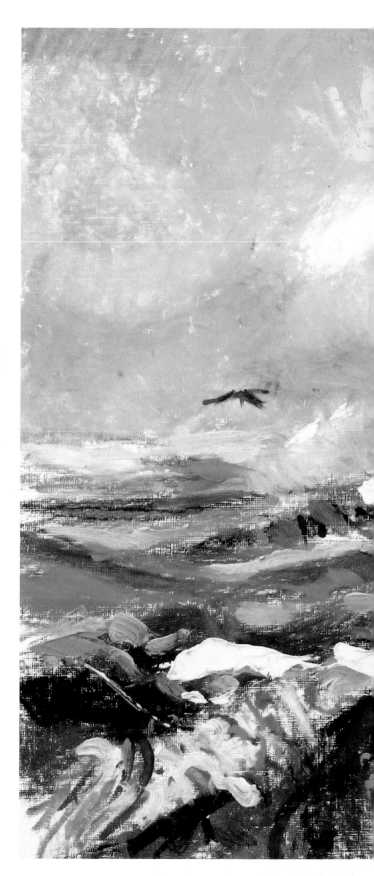

14

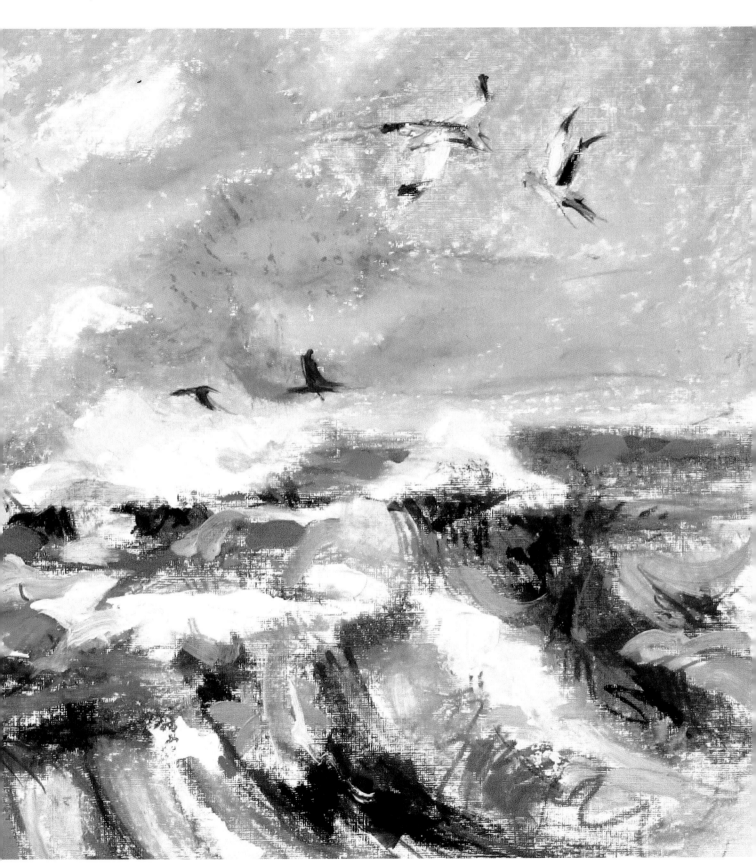

Wild Water, oil paint and oil pastel, 15 x 19" (38 x 48cm)

The materials you'll need for this project

Support
Textured acrylic paper

Drawing tool
Thick graphite pencil

Artist's Quality Oil Paints

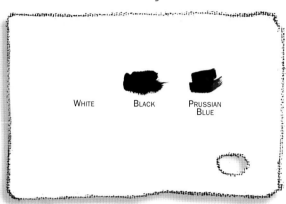

WHITE BLACK PRUSSIAN BLUE

Artist's Quality Oil Pastels

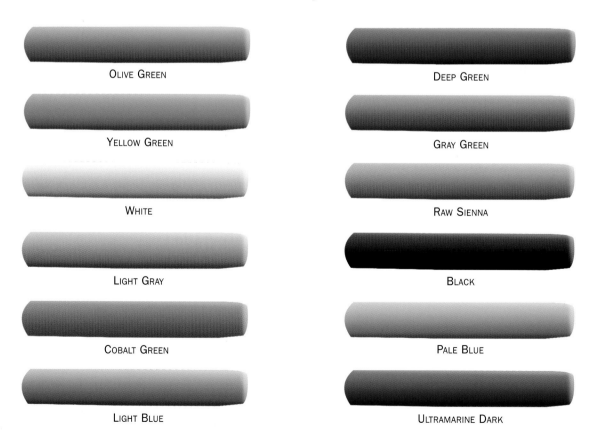

OLIVE GREEN	DEEP GREEN
YELLOW GREEN	GRAY GREEN
WHITE	RAW SIENNA
LIGHT GRAY	BLACK
COBALT GREEN	PALE BLUE
LIGHT BLUE	ULTRAMARINE DARK

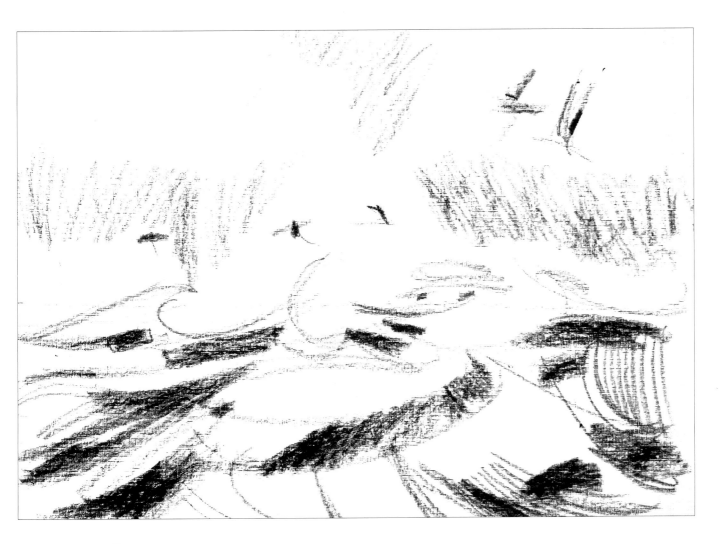

Step 1

Sketch in the main shapes

The effect we want to achieve here is movement! Using a thick graphite
pencil, outline an impression of the wave shapes and suggest a direction
for the sky. Include a few marks to suggest the birds. Work loosely right at
the start, because that's how we mean to go throughout!

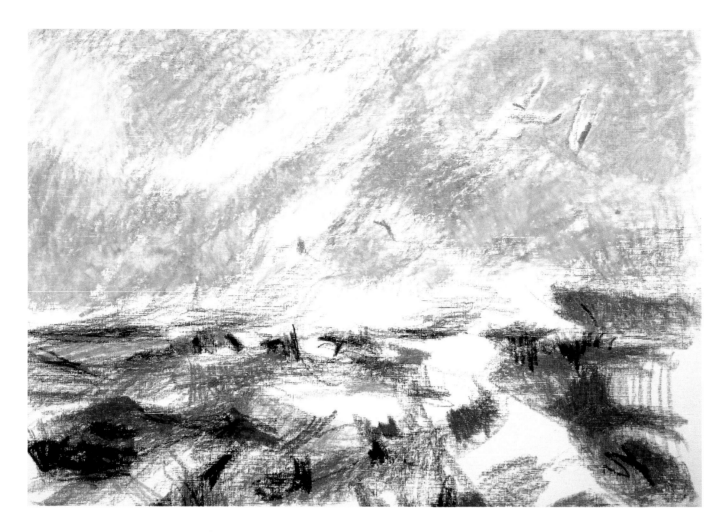

Step 2

Establish the tone

Use Pale Blue, White and Light Gray for the sky. Yes, there's green in the water, so let's establish Deep Green, Olive Green and Yellow Green areas. Touch in some Raw Sienna to establish the rocks. In the foreground place some vivid, loose patches of Ultramarine Dark, Cobalt Green and black.

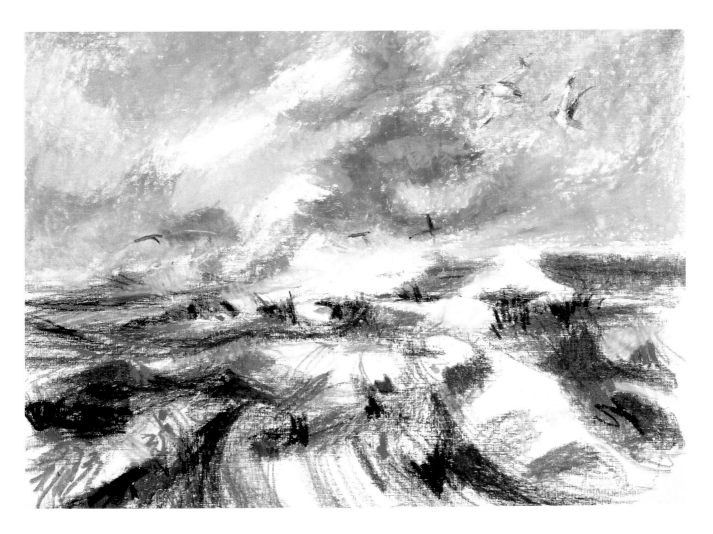

Step 3

Add color

Introduce more color now and darken the main features, the sky and the foreground waves. Let's do more with the sky, to make it more of a counterpoint to the swirling waves. Use more Light Gray in the sky. Use White to lighten, and model the clouds with a darker gray. Add more colors into the waves, trying to maintain the lively effect. Get some directional strokes going. Then bring back the birds by tipping them with Ultramarine Dark.

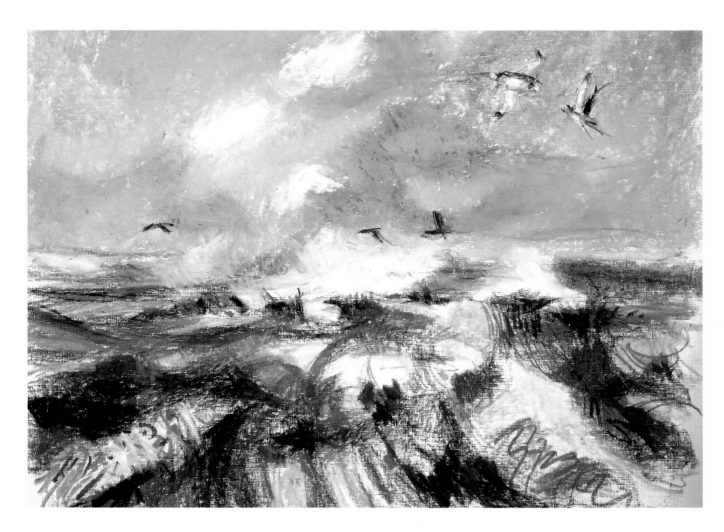

Step 4

Strengthen the effect

Apply more strokes with great weight to strengthen the effect. Maintain the energy of your strokes, and make sure you retain the busy feel of the scene. You are making a much more substantial statement. Introduce Yellow Green, Light Blue, Pale Blue and White into the waves. Loosen up with some squiggles of Deep Green. Touch some black to suggest the three low-flying birds, and add strategic dabs to the two larger birds.

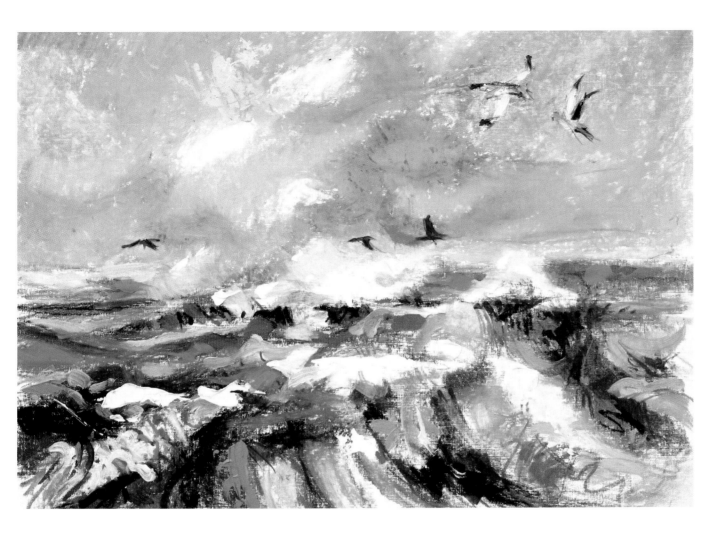

Step 5

Emphasize and detail

Next, tone (darken) the undersides of some waves with Black and Prussian Blue oil paint to give them more form. Emphasize the white-tops using White oil paint. Connect the waves with Deep Green and Yellow Green. Add Raw Sienna accents to the birds. At this stage this is a very free painting. Let's keep it that way, rather than go on to draw details on the birds and rocks. We've said it all!

PROJECT 2 OIL PASTEL: *RUB AL-KHALI DESERT*

Layering and scraping oil pastels to suggest a mysterious desert scene

Travelling around Yemen I was fascinated by the vast contrasts in landscape. At one point I climbed to the tops of rugged mountains, once the source of exotic fruits from mist-laden terraced gardens; at another point I experienced evidence of a much older civilization, the home of the Queen of Sheba. Yemen has one of the largest sand deserts of the world, the Rub al-Khali, or Empty Quarter. There, golden sand dunes rolled away, edged by rocky outcrops. There was plenty of inspiration, and it had to be captured. On my return I tackled the subject in oil pastels, and thought this would make an unusual subject for you to try.

Before you begin, read the entire project through so you know what's going to happen in each stage.

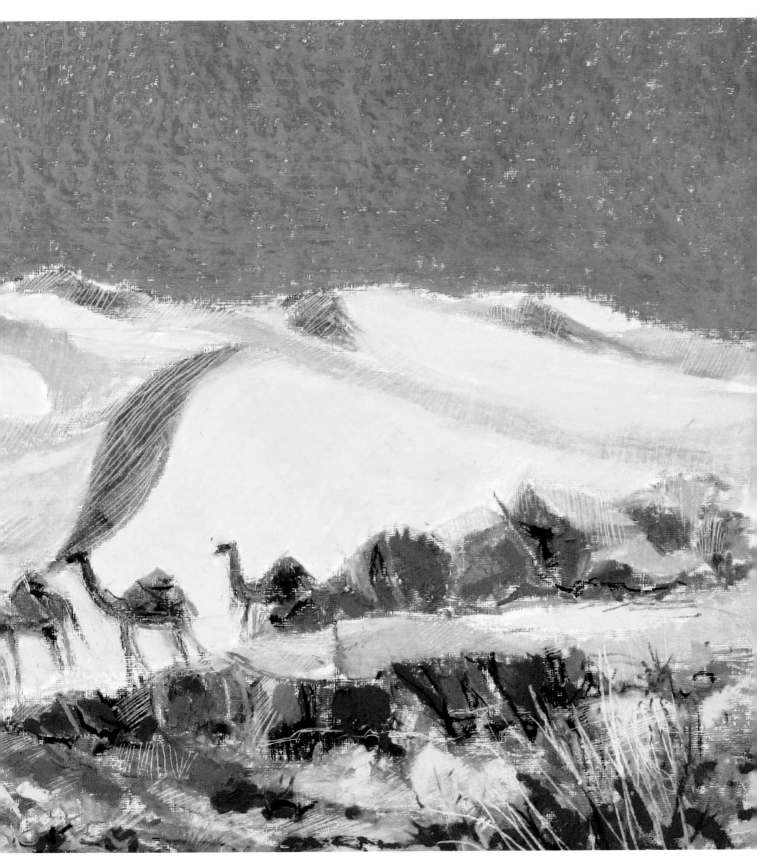

Rub al-Khali Desert, oil pastel, 15 x 19" (38 x 48cm)

Learning points

The challenges

- To use bold sweeping lines.
- To create interesting patterns.
- To take control of color and tone

What you'll learn

- How to modify, develop and correct an oil pastel painting.

Techniques you'll use

- Rubbing pastel into the paper.
- Scratching out with a scalpel.
- Layering.

The materials you'll need for this project

Support

Acrylic paper with a textured finish

Drawing tools

Rich brown crayon

Scalpel

Artist's Quality Oil Pastels

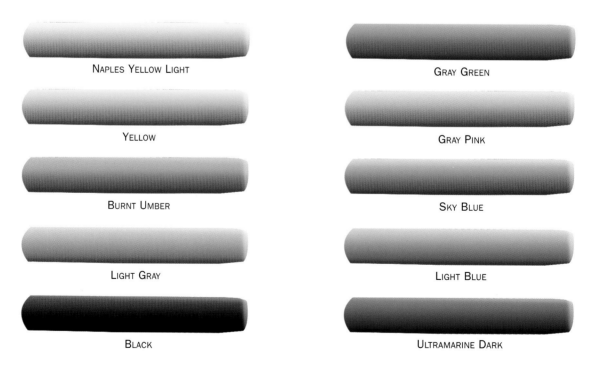

NAPLES YELLOW LIGHT

GRAY GREEN

YELLOW

GRAY PINK

BURNT UMBER

SKY BLUE

LIGHT GRAY

LIGHT BLUE

BLACK

ULTRAMARINE DARK

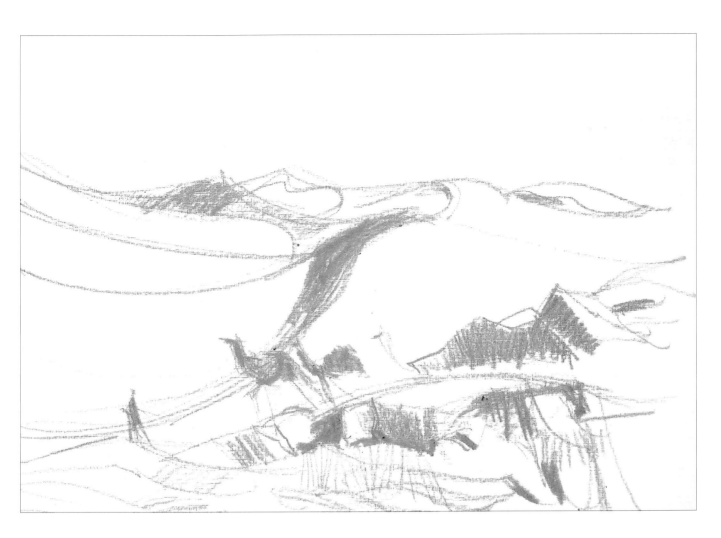

Step 1

Start with the basic lines

The subject lends itself to bold, sweeping lines, so the first step is to make a drawing with your rich brown crayon, just indicating the lines of action. Next, using Burnt Umber oil pastel, roughly place the camels, the figure and the foreground rocks. You have to rub the pastel into the textured surface, which can create interesting patterns.

Design map

Step 2

Rough in the main features

Apply Sky Blue and Ultramarine Blue for the sky. Because of the nature of pastels, patches of white acrylic paper will peek through. Be aware that you have to layer pastels until you get the tone, color and smooth, blended effect you want. Later, you will tone the sky color down. At this stage you just want to cover the paper with a base layer. Already the balance of color is obvious. But these are early days, and at this stage we are merely trying to cover the support for future work.

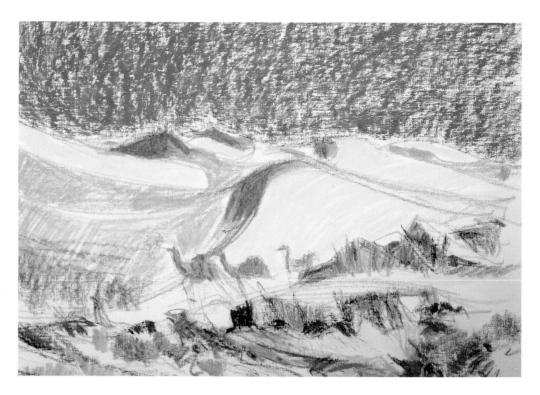

Step 3

Increase color depth

Build up the sky with another layer of Light Blue. Although the sky looks flatter and smoother, it is still too dark. But you'll attend to that soon. Next, apply more Burnt Umber and Yellow to give movement and form to the dunes. Applications of Naples Yellow Light on the sunstruck faces of the dunes give contrast, but we'll need to work on this some more because they are coming forward too much. Introduce Gray Green, Light Gray, Ultramarine Dark and more Burnt Umber into the foreground. Blend these colors in. Try to stay loose. Develop the camels and figure some more.

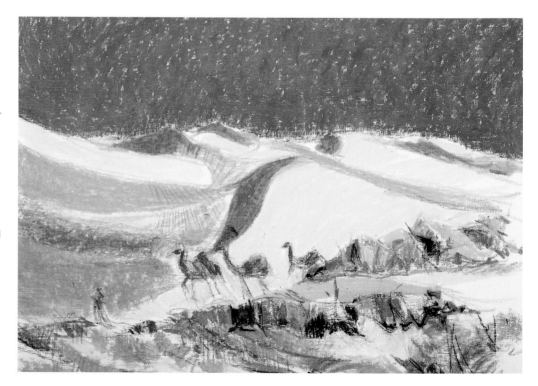

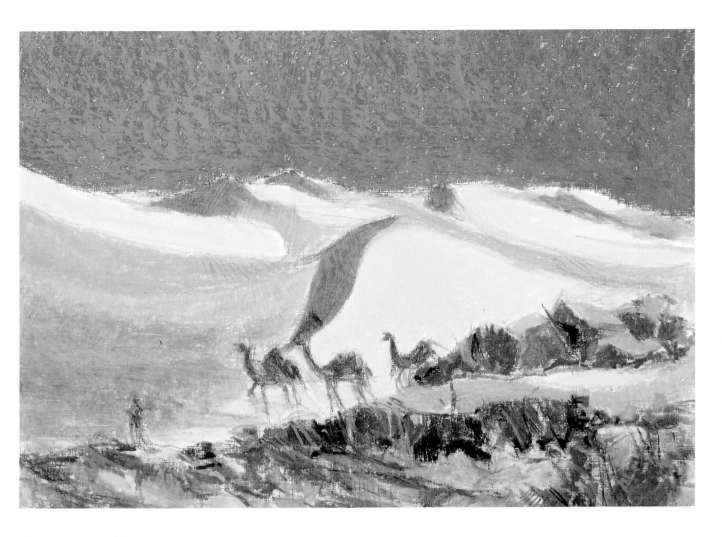

Step 4

Begin to add details

Work in and blend Sky Blue all across the sky area. Now it's starting to look better because it more accurately suggests the real color. Next, tone down the contrast in the dunes by applying layers of Yellow and Naples Yellow Light over the top of the Burnt Umber. Be careful to preserve the sunlit dunes and apply more Naples Yellow Light in these areas. Try to get detail and interest into the rocks and place the camels just beyond them. As you will see, the colors are getting stronger but they may have to be toned down later. This is very much a period of experimentation.

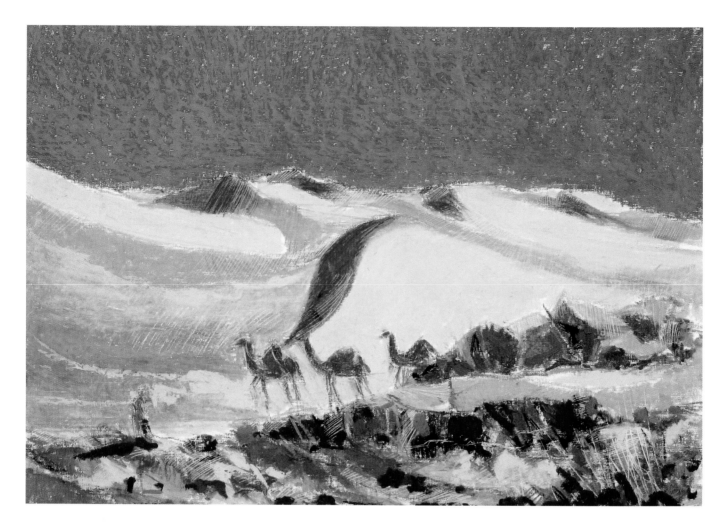

Step 5

Scrape for tone

Now we're going to do some interesting stuff. Pick up your scalpel and scrape away some pastel in parallel lines. In effect you are creating another aspect of tone. Notice the direction of the scrapes I made. They are fairly uniform in direction, and they follow the form of the dunes and the structure of the rocks. Next, increase the purples and pinks in the foreground. The painting is still a bit bright.

Developing the camels

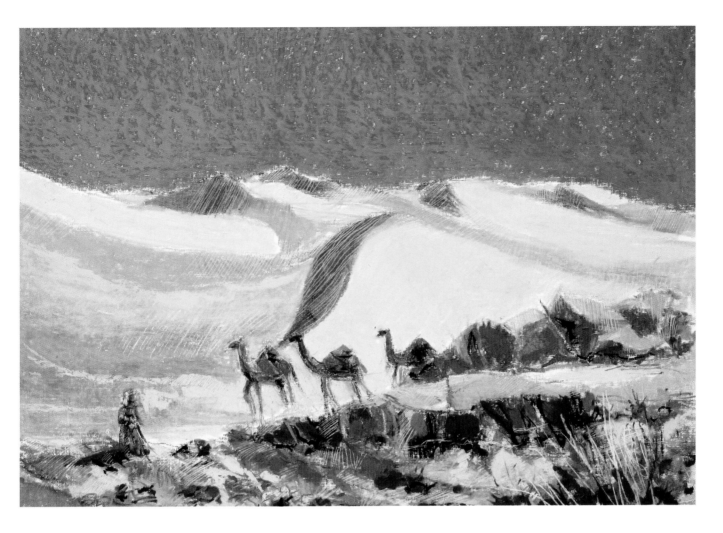

Step 6

Sharpen details

As I've said elsewhere, any sort of creative painting means thinking problems out as they occur. Oil pastels, with all their difficulties, do offer opportunities to change the work at a late stage. To do the same in watercolor would require considerably more skill.

In this last step we will tone the dunes back by scraping them even more. To bring the foreground rocks forward we will sharpen them up bit. Tone down the Ultramarine Dark areas with Light Gray and Sky Blue to the top, light-struck faces of the rocks. Once the foreground colors have been toned, use your scalpel to cut in and suggest some desert grasses. The overall effect is now a better whole. The painting is still impressionistic, due partly to the medium, but that's fine because it conveys the mystery of the desert.

Developing the figures

PROJECT 3 GOUACHE: *JARDIN MAJORELLE*

Controlling color and tone in a sunstruck garden

I knew about this garden long before I got to Morocco. It had been described as a Moroccan oasis. Its beauty lay in the style of the buildings, particularly Villa Oasis, and in the colors. Because of the climate the garden always needs care and attention. The impression was of new plants ripening then decaying plants all evolving in a real-life mystery.

The house and garden were saved from ruin by a number of people, notably Yves St. Laurent and Pierre Berge. They brought life back to the villa and other structures and replanted the garden. The impression I got was blue. The shadows from shrubs and palm trees created patches of depth and brightness, power and magic. It was a step out of the cacophony of the bazaar into a more elegant past. Trying to capture this was not an easy task.

I went mid-morning, perched on a stone kerb and began to sketch. I hadn't got far when we were ejected for the lunch break — three hours! I never went back, but I had my sketch and photographs to work from. This project comes from my references.

Before you begin, read the entire project through so you know what's going to happen in each stage.

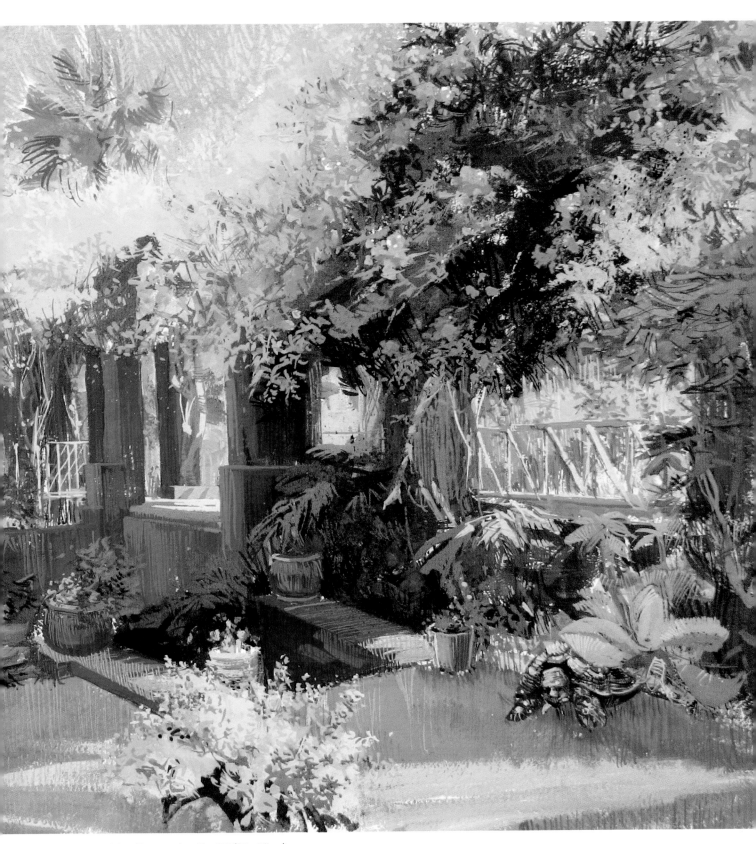

Jardin Majorelle, gouache, 13 x 20" (33 x 51cm)

Learning points

The challenges

- To convert an impression into a painting.
- To work out compositions accurately.
- To work quickly and brashly.

What you'll learn

- How to manipulate blues and greens.
- How early deficiencies can be eliminated later.
- How to juxtapose warm and cool colors.
- How to develop tonal contrast.

Techniques you'll use

- Big brush strokes.
- Layering.
- Calligraphic stokes.
- Scraping.

The materials you'll need for this project

Support

140lb watercolor paper

Drawing tools

Thick graphite pencil
Big flat brush
Round brush
Rigger brush

Artist's Quality Gouache

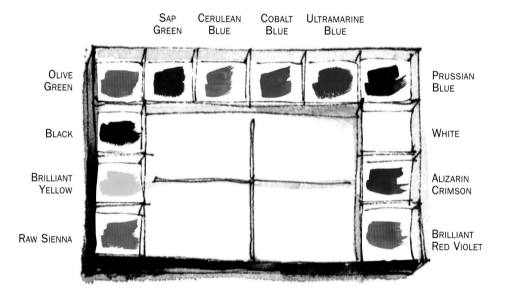

SAP GREEN CERULEAN BLUE COBALT BLUE ULTRAMARINE BLUE

OLIVE GREEN

PRUSSIAN BLUE

BLACK

WHITE

BRILLIANT YELLOW

ALIZARIN CRIMSON

RAW SIENNA

BRILLIANT RED VIOLET

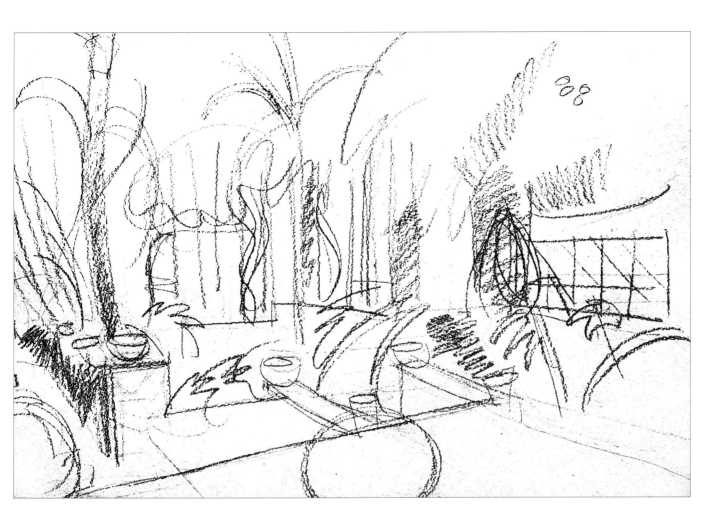

Step 1

Make a rough sketch

We will use the verticals as our guides for this complicated scene. Sketch in the tree trunks and the building uprights. Once you have these in place, you can roughly sketch the steps, walls and bridge lines. Observe correct perspective in the beginning. Suggest the swirls and oval shapes of vines, foliage, pots and palm fronds. Notice the strong diagonal line in the foreground.

Step 2

Wash in the main shapes

First, wash in the blue walls, uprights and steps for the building using Ultramarine and Prussian Blue. Use your big flat brush. Next, define the floor using a thin wash of Brilliant Red Violet. Merge some Alizarin Crimson in the foreground. Drape the vines and suggest foliage using your greens, with some Brilliant Yellow allowed to blend wet-in-wet for the sunstruck areas. Add the Cerulean Blue pot shape in the foreground. Suggest a circular area of green for the foreground foliage. Develop the sky. Wash in the darker side of the main date palm trunk. Indicate some palm fonds. Use Alizarin Crimson and White to develop the pink floor, and introduce some light, sunstruck strokes. Mix some green into Raw Sienna and define the palm trunk, suggesting its structure.

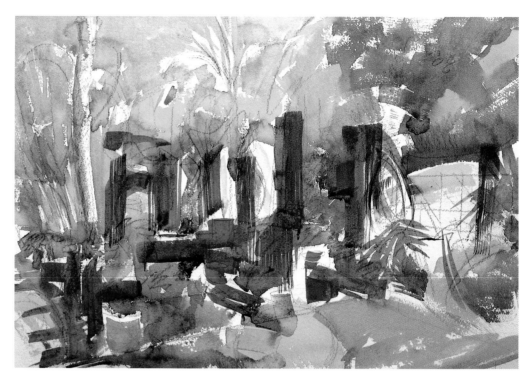

Step 3

Intensify the greens

Now the greens. There are many different plants growing around this building, from vines and floral trees to beautiful potted plants and flowering shrubs. It is important to establish what plane each plant occupies and to determine how far to permit the background to encroach. Use strong, opaque Sap Green for the darker greens; watery Olive Green for the palm leaves and major foliage on the left. Mix in some Brilliant Yellow to retain the highlights. Use Cerulean Blue and White for the sky. Then develop the light and dark blue building elements.

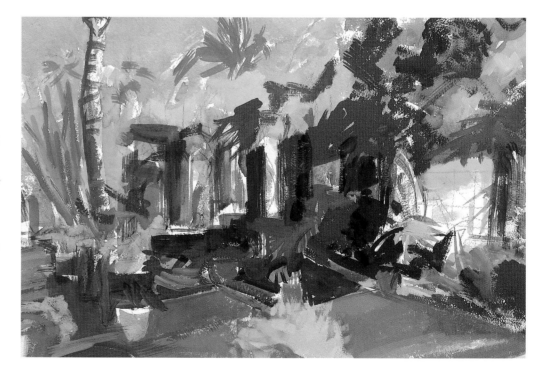

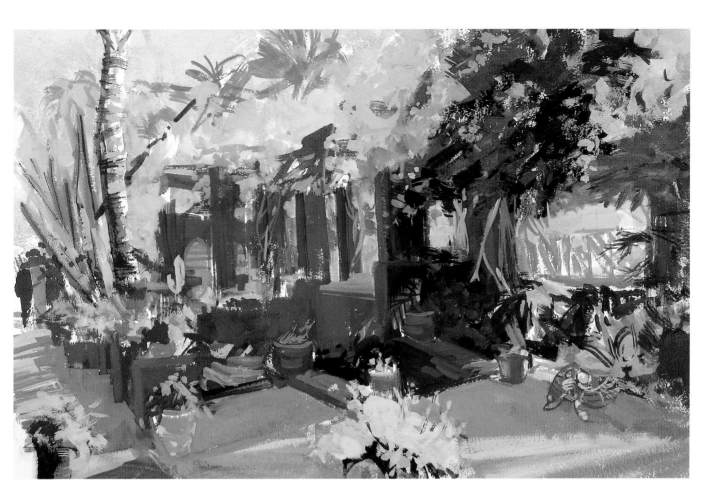

Step 4

Increase definition and tone

More definition is called for in the plants, as well as a descriptive interpretation of the other features in the building's layout. Use your fairly big brush and slabs of strong color because it is still a time for establishing the main elements. This style demands working quickly and assertively.

At this stage we are strengthening the dark tones and accentuating the light tones. All good paintings have tonal contrast. Accordingly, use Sap Green and Black as I have done. Strengthen the lighter foliage. Develop the floor, pots, and introduce Raw Sienna for pillars, floors and to suggest the bridge supports. I think this garden needs a giant tortoise, so let's introduce its shape in the foreground. When everything is dry, you can enjoy dabbing in some blossoms using combinations of Alizarin Crimson and White and Brilliant Red Violet and White. Opaque gouache allows you this privilege. Mix up an orangey-brown for the vines and woodwork. Notice the introduction of a diagonal palm trunk at top left.

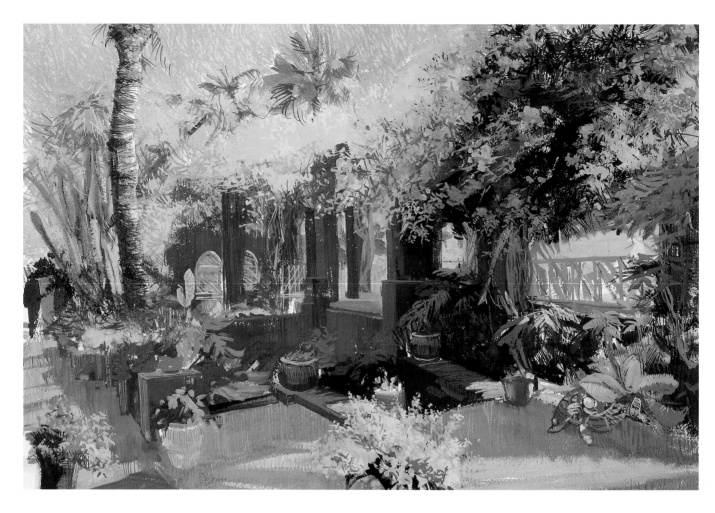

Step 5

Detail the foreground plants

Now we can really increase the definition. Use your rigger brush to develop the palm fonds, leaves and details, working over the entire painting. Detail the foreground pot foliage, the bamboo, the various accents of color for the plants. Then apply Cerulean Blue and White on the sunlit planes of the blue walls and use the end of your thin brush, or your scalpel, to scrape out some texture lines. Add calligraphic black details and do the same with calligraphic light lines. We're really getting the feel of this sun and shade garden courtyard. Notice the treatment of the warm and cool pinks on the floor.

Also notice the way I defined and enhanced the main palm trunk. Be careful to retain the highlights when you do it.

Develop the sky now, with short strokes of Cerulean Blue and White overlaid on the original Cobalt and White wash.

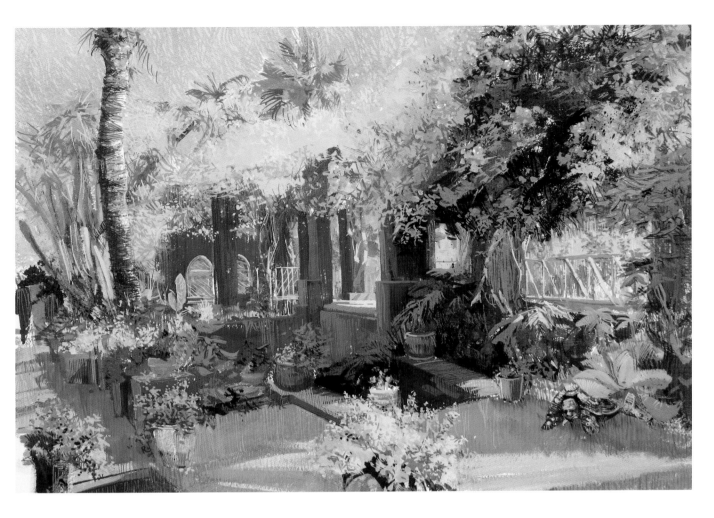

Step 6

Add final details

Add calligraphic lights. Bring the foreground pots to completion. Add highlights to bamboo lattice and bridgework and highlight the vines. Repeating color throughout helps to unify the painting. Then enjoy finishing the tortoise munching on a leaf. I think we've captured the essence of this busy garden in Morocco.

Developing the blue pot

How to suggest a mass of detail without actually doing it

Many years ago the Tremayne Estate in Cornwall, England, had magnificent gardens. But in 1918, as happened with so many other great estates, it suffered the loss of staff who for one reason or another failed to return to work after the First World War. To make a long and amazing story short, the imagination of one man, Tim Smit, has resulted in the rebirth of a wide variety of garden layouts including "The Jungle" at the Tremayne Estate.

Arriving at the Tremayne Estate on a fairly dull day without a camera, I decided to walk through The Jungle. It's now a valley of pools from times past, which has been rebuilt and replanted with tree ferns and jungly vegetation, set off with a background of rhododendrons.

This picture then is 'The Jungle' at Heligan. By looking at the result you will no doubt have understood the challenge. Fortunately it was the season when most rhododendrons are at their best. In addition there were tree ferns, swaths of enormous gunnera, primulas and lilies, conifers and bamboos. I enjoyed a gentle walk down through this ever more dramatic setting and back up to the top.

Before you begin, read the entire project through so you know what's going to happen in each stage.

HELIGAN

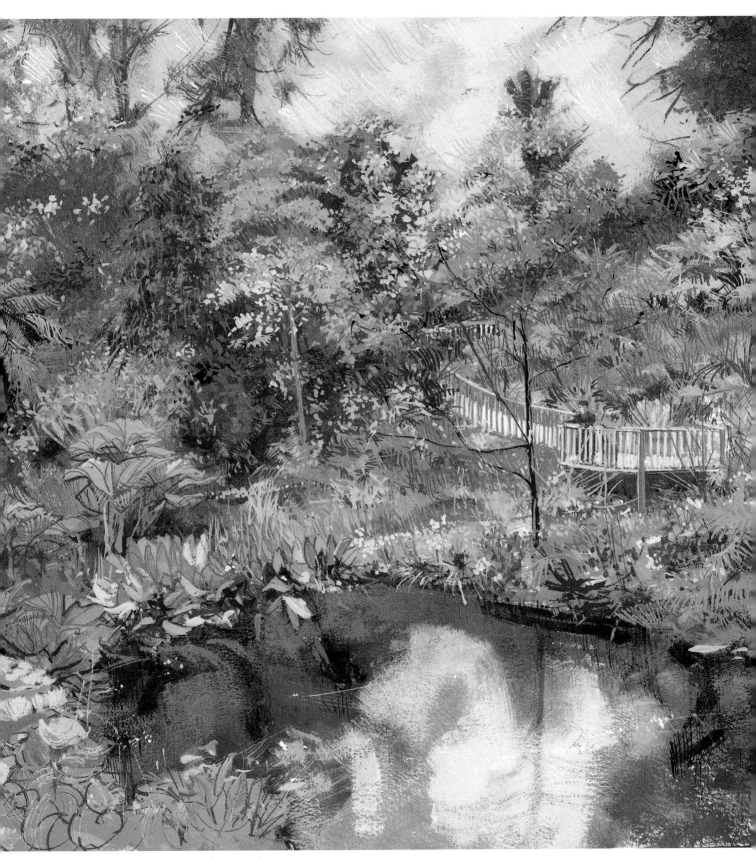

Los Gardens of Heligan, gouache, 13 x 20" (33 x 51cm)

Learning points

The challenges
- To establish a pattern for the composition.
- To establish a flow.
- To avoid being overwhelmed by details.
- To separate the various major elements.
- To copy with all those greens.

What you'll learn
- How to sketch in color.
- How to use opaque color.
- How to paint reflections in water.

Techniques you'll use
- Blocking-in.
- Toning.

The materials you'll need for this project

Brushes
Large flat
$^3/_8$" flat
Rigger

Drawing tool
Thick graphite pencil

Artist's Quality Gouache

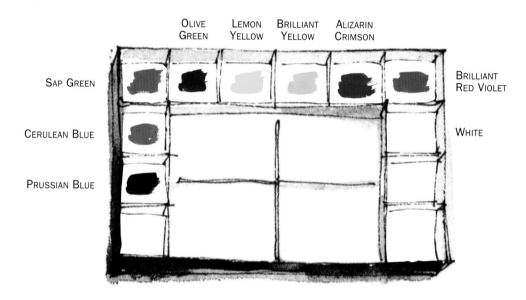

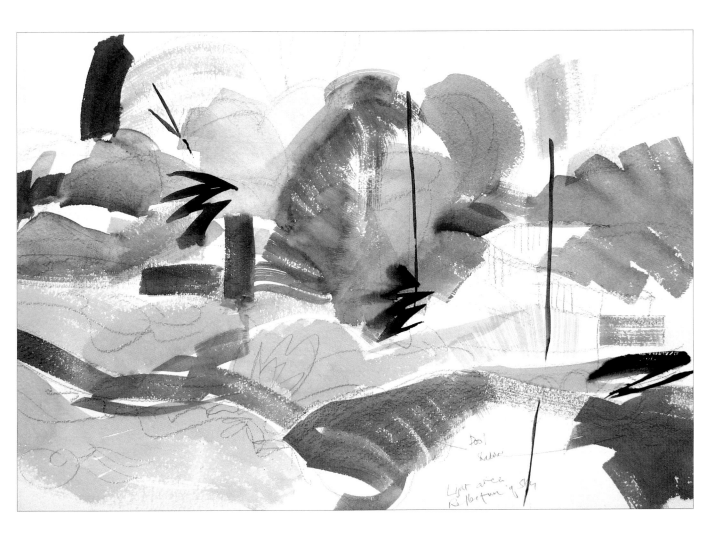

Step 1

Sketch the outline

It is important to outline a pattern, or a set of compositional rules, for a painting. There is so much going on that it would be easy to become overwhelmed. So, first, sketch in the major planes to establish a flow. And, second: separate the various major elements, meaning the sky, the tree background, the foreground and finally the pond.

As you will appreciate, there is no detail at this stage, just form and a bit of color. So use a large flat brush for the bold lines and blocks of color.

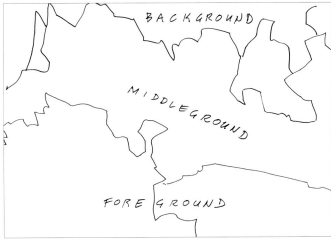

Step 2

Apply opaque colors

Now apply opaque color more boldly. Use smaller brushes, but make no attempt to fiddle with detail. We now have a basic shape and a guide to the final tone and color plans. The pond will reflect the sky, and there is a horizontal band of foliage blocks running across the painting. All those greens will be relieved by strategic pink and white flowers, with the circular pathway balancing the circular foliage in the bottom left.

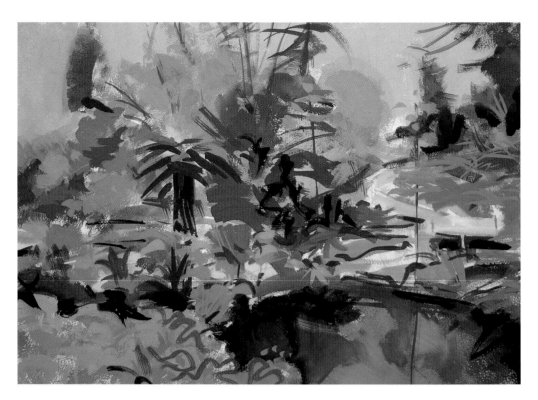

Step 3

Strengthen the shapes

In this strengthening stage, you will more clearly distill the elements. The colors should be more accurate, the brushwork done using smaller brushes and this time you'll add details and line work. Even at this early stage the scene is taking shape. Notice how the pond colors were built up, and how some very dark passages have been established.

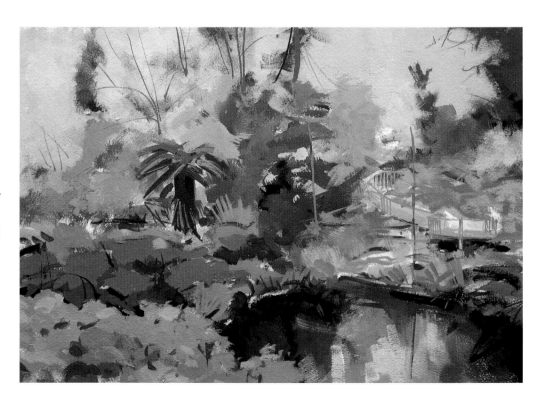

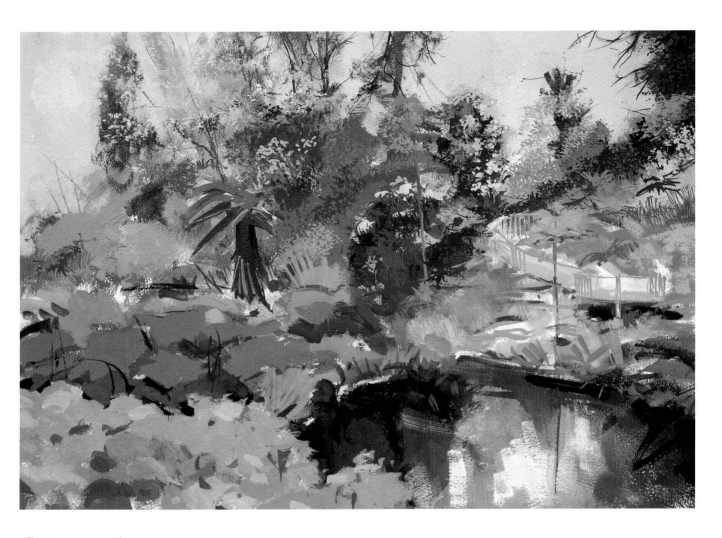

Step 4

Add details

If you are very skilful, and want to do so, it is possible to create an image in a few simple brushstroke. Any more can spoil the effect. On the other hand, you may choose to elaborate on detail to best achieve the effect you want. Here we want to suggest a mass of detail without actually drawing it in. I suggest we start top left and work across to the right. Combine a mixture of flat brush-toned work and detail work put in with a rigger.

The toned areas can be very effective and save considerable time. For instance, you can model the top of a tree so this suggests a mass of detail without actually drawing it in. At this stage we have maintained an effect that has not swamped the foreground.

Step 5

Refine the details

Keep developing the suggestion of detail, working left and down. I use small brushes at this stage because, although much of the paint looks to be boldly applied, there is considerable line work, such as around the big plants to the left of the pool.

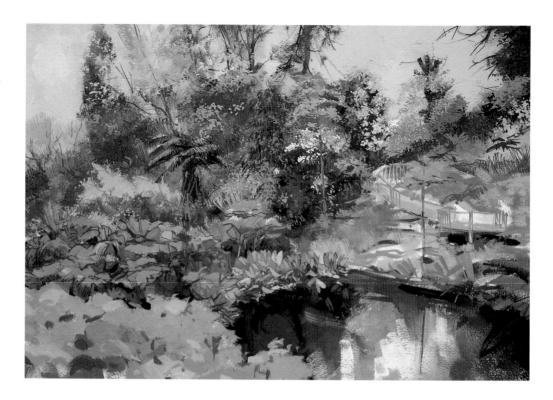

Step 6

Assess for weaknesses

Now you can see the full picture, incomplete but getting there! You have brought almost all areas to a general finish, except perhaps the foreground lilies.

This is the point to be brutally critical. Just sit and look! Does any one area look too strong or too weak against the rest? Should you be holding back or emphasizing vegetation or reflections? Does the boardwalk stand out too strongly? If you have a frame or a mount, put your painting in it and take it somewhere neutral. Or ask other people's opinions (happily keeping in mind that you don't have to agree with their views!).

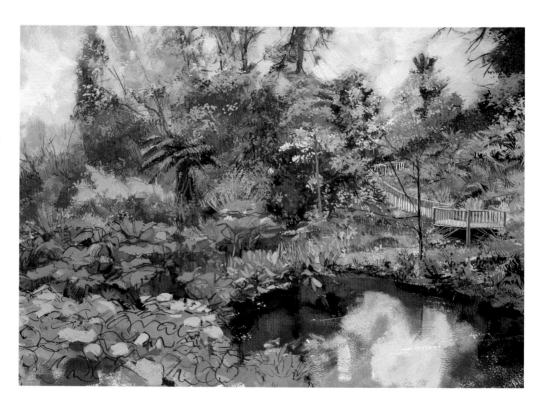

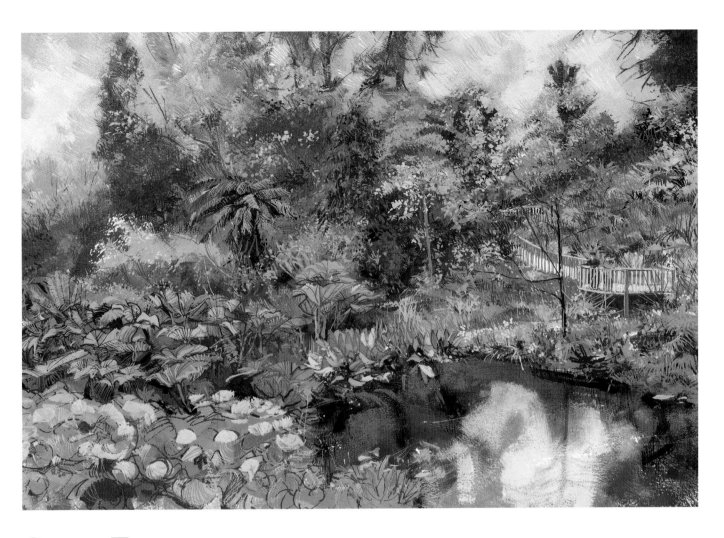

Step 7

Paint final details

Work over the whole picture, soften areas of overemphasis, better define the tree fern, add detail to the foreground to make the plants look substantial but not too botanically perfect. Break the line of the boardwalk because it hinders the natural look of the place, despite its value as a tourist-friendly feature. Add some people too. Although you will have painted using a small, thin brush, the overall effect looks as if it was painted freely.

Suggesting water

 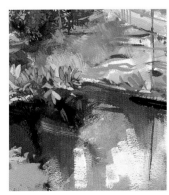 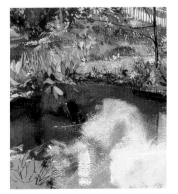 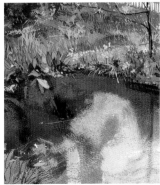

PROJECT 5 OIL: *SUNLIGHT ON THE RIVER TAW*

How to handle the relationships in a colorful, dynamic scene

This painting arose from a commission to paint a fisherman's favorite spot on the river. When evaluating a subject the first step is to work out not only the composition of the scene, but also the best way to present it. I painted both a gouache and an oil painting, then a second and larger oil. This demonstration is a recreation of the smaller oil in a lighter, brighter form. It is an impression, not a record, of vegetation and water levels.

The intention in this project is to show sunlight reflecting on a very blue swirling stream and the colorful fall foliage on a surprisingly lovely autumn day in Devon.

Before you begin, read the entire project through so you know what's going to happen in each stage.

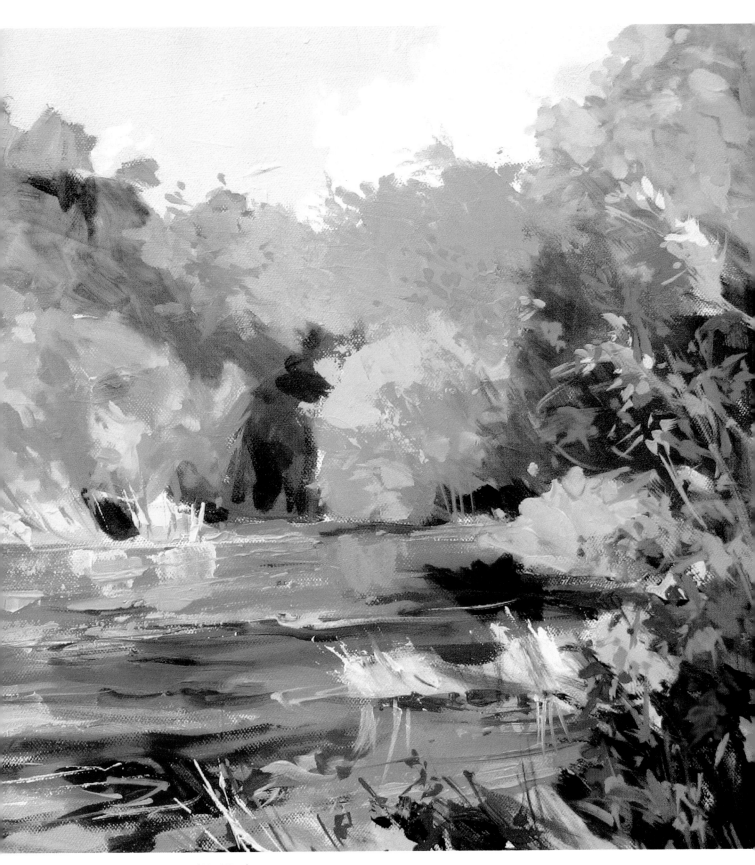

Sunlight on the River Taw, oil, 18 x 22" (46 x 56cm)

The materials you'll need for this project

The challenges

- To avoid painting too large.
- To depict swirling water.
- To retain a scene's balance.

What you'll learn

- How to sketch with quick-drying alkyd oils.
- How to control a bright scene.
- How to delineate forms.

Techniques you'll use

- Rigger brush work.
- Overpainting.

The materials you'll need for this project

Support

Stretched canvas, canvas paper
or canvas board

Odds and ends

Thick black graphite pencil
White gesso
Quick drying painting medium

Brushes

Medium size round and flat bristle oil
painting brushes
Rigger brush

Artist's Quality Oils

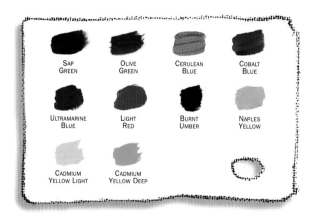

NOTE: You can use quick-drying alkyd oils, or add a quick drying medium to your paint.

Step 1

Sketch in the main shapes

I shall be using alkyd quick-drying oils. (I usually do anyway, but with a staged demonstration one needs the paint to dry rapidly in order to apply the next step without delay.) You can choose to use a quick drying medium to spped up the drying process.

First, apply a coat of white gesso to your canvas to provide some underlying texture. When that is dry, roughly draw in the main shapes using your graphite pencil. Notice that the lines are free and circular.

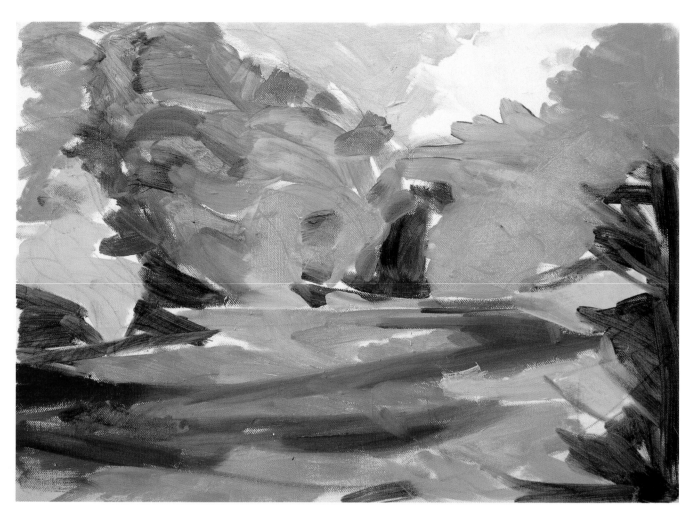

Step 2

Block in the first colors

The first application of paint sets the scene. At this stage there is no desire to establish more than an effect and to block in areas of tree and water. This is going to be a bright picture, so we'll start with bright colors. Using thin paint mixed with painting medium, wash in the main shapes of color. Introduce darker bands of color into the water, the distance and on the banks and foreground.

ULTRAMARINE BLUE

CADMIUM YELLOW DEEP

LIGHT RED

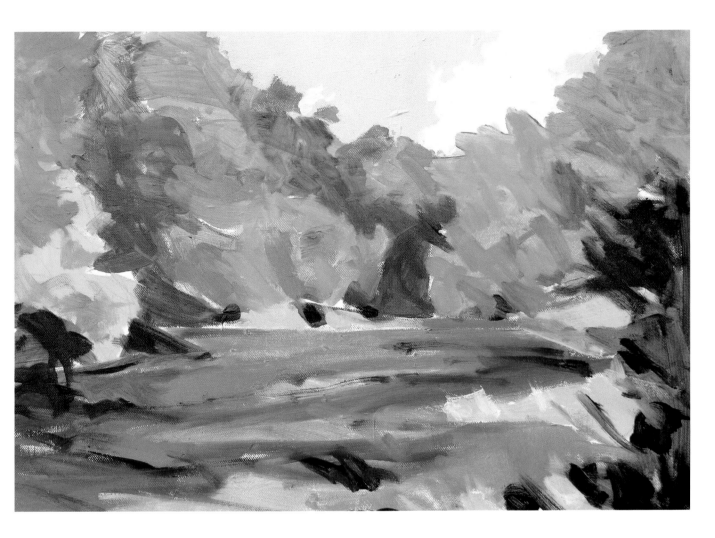

Step 3

Delineate the forms

Using thicker paint, gradually delineate the forms of the main features — the trees, the island, and the swirling water. It is important to show movement in the water because the river is flowing rapidly. It is also being affected by the land projections on either side. Try to keep your colors pure and bright. Mix up some Cerulean Blue lightened with white for the sky, then introduce the fluffy white cloud.

CERULEAN BLUE

BURNT UMBER

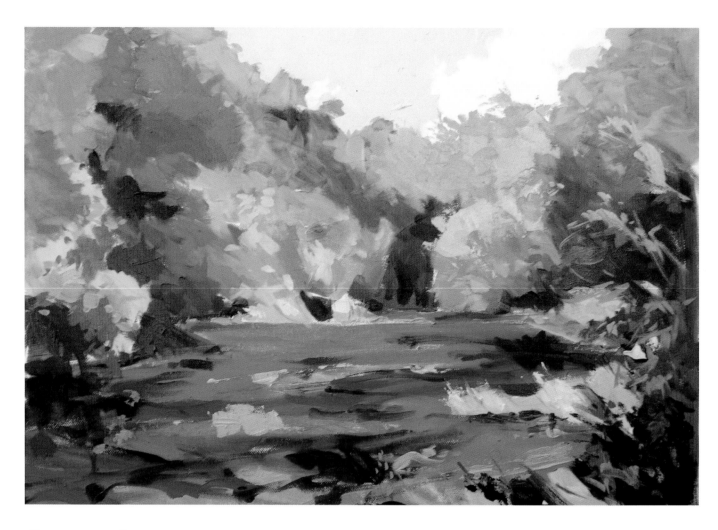

Step 4

Increase detail

We will develop the trees on the left and the foreground and add autumn tints. On the right I show more detail in the bank running away from us, which incorporates a further projection and overhanging trees. The river, too, is busier. Start suggesting the effect of distance by introducing warmer color into the foreground trees. Notice the passages of Light Red and Cadmium Yellow Light. Lighten the background trees and gray off the distant hillside. Introduce more color into the river using Ultramarine Blue, Cobalt Blue and Olive Green mixed with white for the foliage reflections. Horizontal strokes help suggest water.

COBALT BLUE

CADMIUM YELLOW LIGHT

OLIVE GREEN

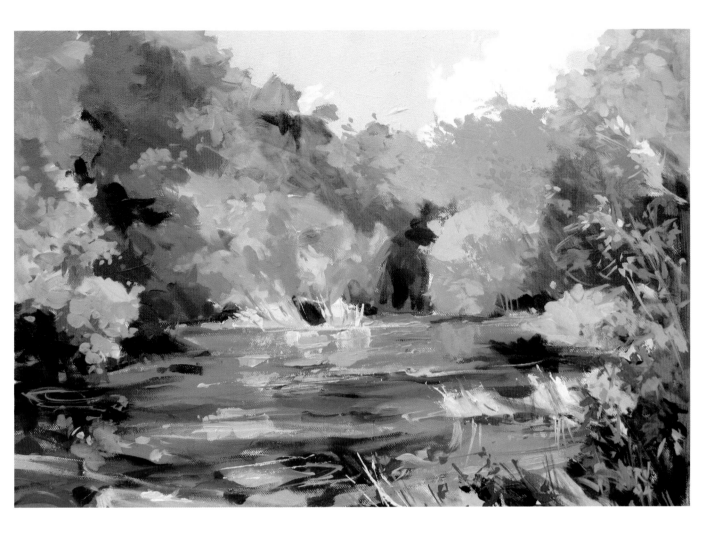

Step 5

Bring the river to completion

Remember though, that this is an "impression" of the river. Use your rigger brush to introduce more light colors, suggest some swirls and ripples with calligraphic lines, and introduce some foreground grasses, leaves and color accents. Don't fiddle too much — those rigger brushes can lead you astray. The extra work done on the river confirms it as the main subject.

I hope you agree that the picture now has an active look about it, with all the feature relationships in balance.

PROJECT 6 OIL: *AUTUMN COLOR AND REFLECTIONS*

How to use bold brushwork and control color to achieve mood

I paint all year round and try to cover as many seasons as possible. There are of course four, with all the variations that English weather can throw in. Autumn in England, with a favorite water venue, can probably provide all the challenges and moods one could ever manage.

The medium we shall use for this project is oil on canvas, with loose brushwork that will be tidied up later with a smaller brush for tree detail and to liven up reflections.

The first challenge is to control the autumn color. The second challenge is to paint in a free style using bold brushwork.

We will use a fairly simple, bold approach with nothing too fancy or elaborate. We are going to block in the shapes of the trees and their reflections without making too much of it and then we're going to tone the color back to suggest a moody English scene. I wanted to include the old boathouse because I found out it was going to be refurbished in the near future and I wanted to record it for posterity.

Before you begin, read the entire project through so you know what's going to happen in each stage.

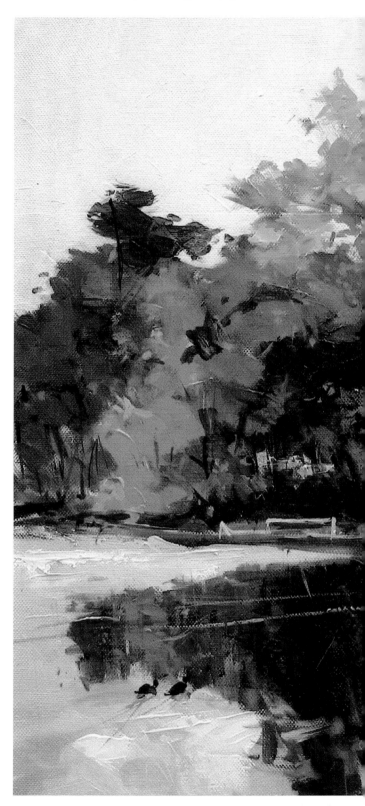

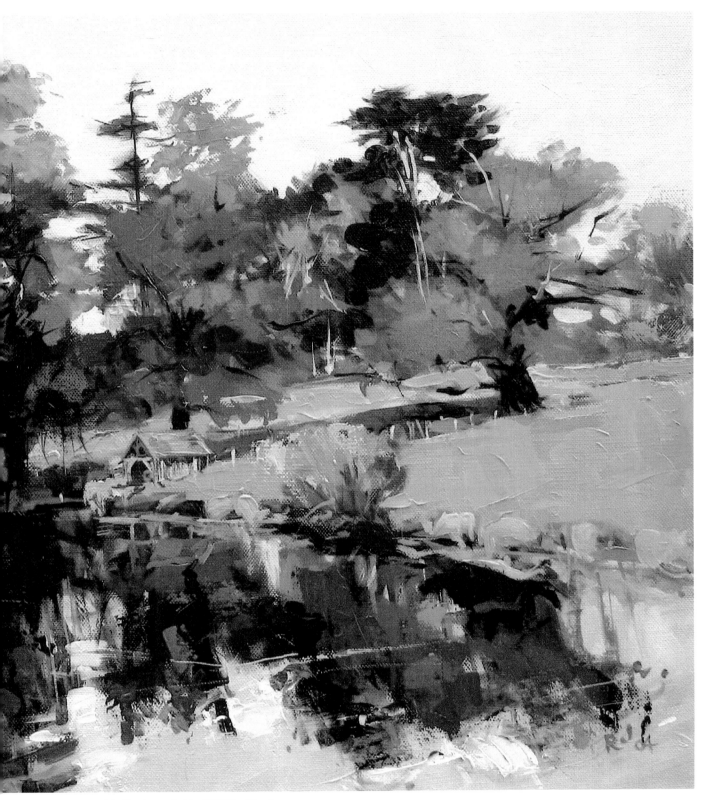

Autumn Colour and Reflections, oil, 16 x 22" (41 x 56cm)

Learning points

The challenges
- To control color.
- To retain freedom of brushstrokes.

What you'll learn
- How to use loose brushwork.
- How to define lines.
- How to suggest water movement.
- How to tone down color.

Techniques you'll use
- Drawing with the brush.
- Sketching in angles.

The materials you'll need for this project

Support
Canvas

Brushes
Large to small round and flat bristle brushes
Rigger brush
Oil painting medium

Artist's Quality Oils

PHTHALO BLUE CERULEAN BLUE OLIVE GREEN SAP GREEN

LIGHT RED BURNT UMBER NAPLES YELLOW CADMIUM YELLOW LIGHT

CADMIUM ORANGE PERMANENT ROSE

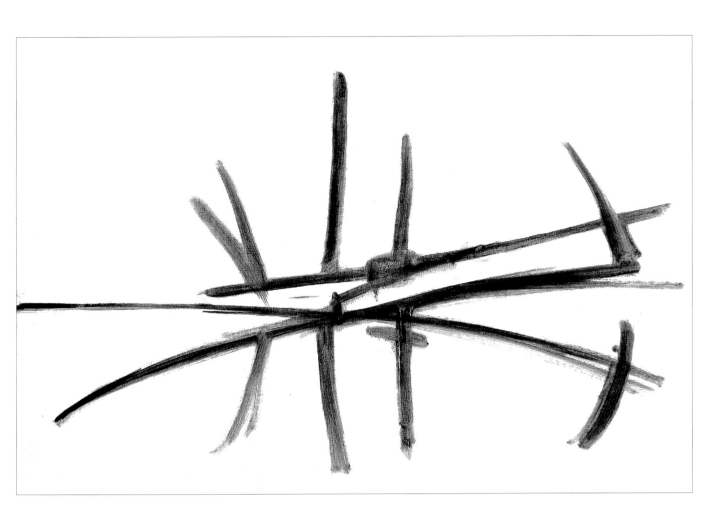

Step 1

Sketch with paint

We won't be undercoating our canvas with white gesso this time. When painting oils I rarely produce a detailed pencil rough, preferring to go straight into color in a bold way. So, let's draw a brush interpretation of how the angles fall. This shows the horizontal and vertical lines of the fields and reflections, and indicates the basic construction of the composition. Use a thin wash of Sap Green for this drawing.

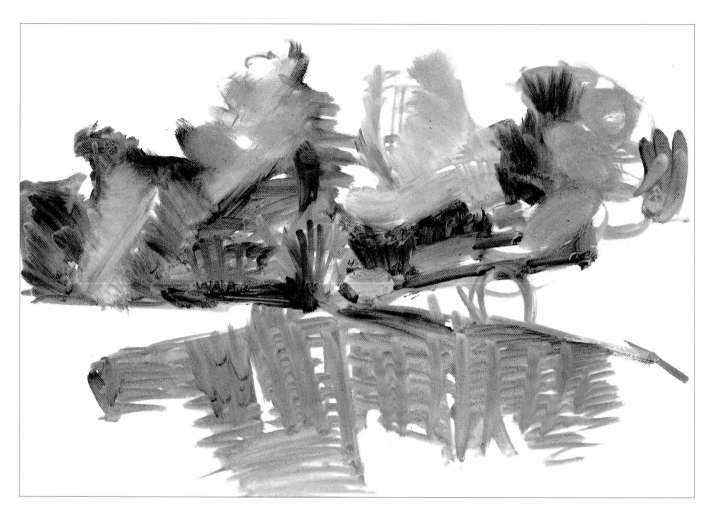

Step 2

Indicate the key areas

Using more Sap Green, apply more solid brushwork to fill in the tree shapes and water reflections. Darker, stronger Sap Green introduces some tone. It is easier to judge the balance of one area against another if one can see them in tone rather than line.

SAP GREEN

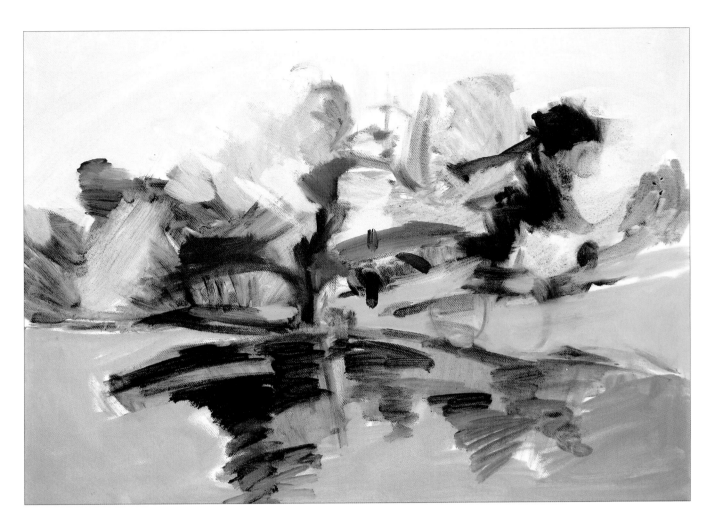

Step 3

Block in major areas

The sky and water areas are major features, the next thing to do is block them in using varying intensities of Permanent Rose and White for a neutral gray made with Ultramarine and White for the water. Strengthen the dark tones even more using Olive Green. There will be an opportunity to add color and interest later. At this stage our goal is to establish an overall look for the work.

PERMANENT ROSE

OLIVE GREEN

Step 4

Introduce strong colors

Now is the time to add the strong colors that will reinforce the message of the picture — a warm autumn glow. Make no attempt to put form into the trees or water, merely brush on enough color interest to create the impression we want. Cover the sky with White. At this stage, everything looks out of focus.

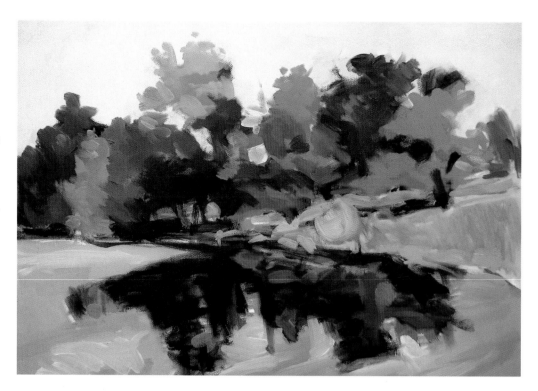

Step 5

Increase definition

Now you can start to bring everything into focus. Define the focal point boat shed, lighten areas throughout the painting. Introduce more tonal contrast by graying the water on the left, adding pure White, and either lightening or darkening strategic areas. Introduce the suggestion of a ragged pine jutting into the skyline, which you should define more clearly. Drag a shadow from the main tree on the right diagonally to the boat shed. Outline the water, and suggest some movement.

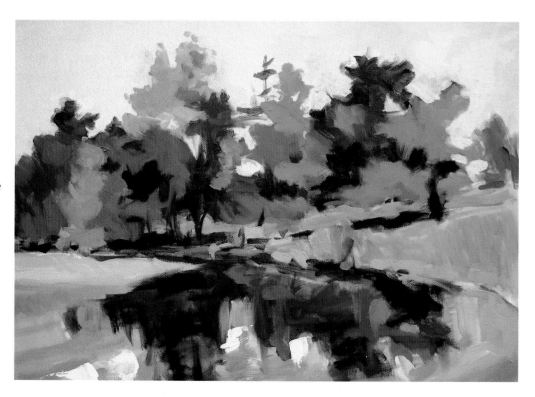

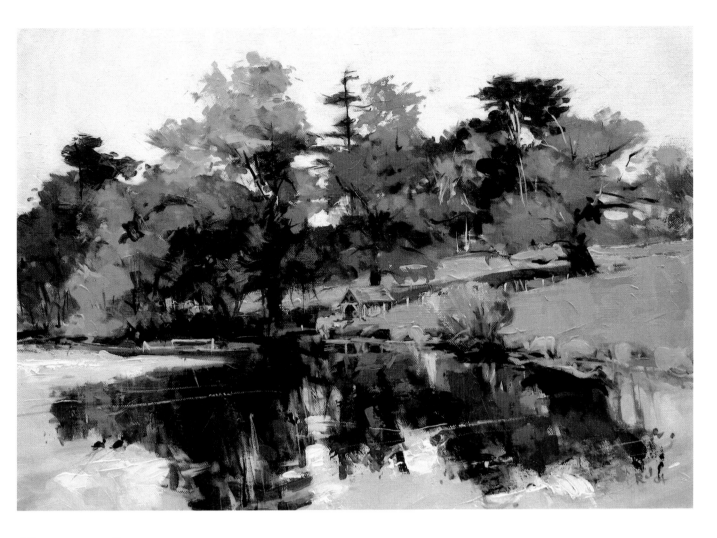

Step 6

Finalize the painting

Now we are going to tone the whole thing down. As you can see, I have used a finer brush to add twigs, water highlights and details on the boathouse. The danger is being too pernickety — gilding the lily! As it is, I think the final effect here is pleasing and does what I set out to do. Muting the color produces a distinctly different mood to the sunstruck riverbank in the previous project. This time we're going for tone. Gray off all the bright green foliage using Olive Green, Burnt Umber and Light Red. Do the same for the reflections, remember to use downward (vertical) strokes, which suggest depth.

Tone down all the yellow, subdue the grass and gray off the sky. This a commonplace atmospheric effect in England and in this painting suggests the first autumn chill. Then start detailing with your rigger and a gray. Paint the fences, tree branches, boatshed and stroke in some confident ripples. Then detail the trees using your rigger and Burnt Umber. Strengthen the darks, finesse the water. Subdue the grass and add those sandy banks with Naples Yellow. The big question is, where to stop? Let's stop before we go too far.

OLIVE GREEN

BURNT UMBER

LIGHT RED

Achieving luminosity and texture with watercolor, ink and gouache

When I paint out of doors in watercolor I usually add ink lines to hold the painting together. First I quickly sketch in the subject, merely to fit it onto the page, then I wash in the main color areas, after which I start working up the detail as far as I think it needs to go.

This creek, off the main Falmouth estuary in Cornwall, was peaceful and backlit. I wanted to introduce the atmosphere of the scene without overdoing the specifics. The original sketch was painted quite quickly because it began to rain and I had to finish it in the back of my car. Since I knew a bit about boats, all this painting really required was an impression.

For this project we will be working on a heavy watercolor paper stuck with tape onto a board. Although it looks bright, there are not that many colors. I recommend you use large, square-ended brushes and a long thin rigger to line it up here and there. The final touches will be some India ink drawing plus a touch of body color.

Before you begin, read the entire project through so you know what's going to happen in each stage.

COWLANDS CREEK

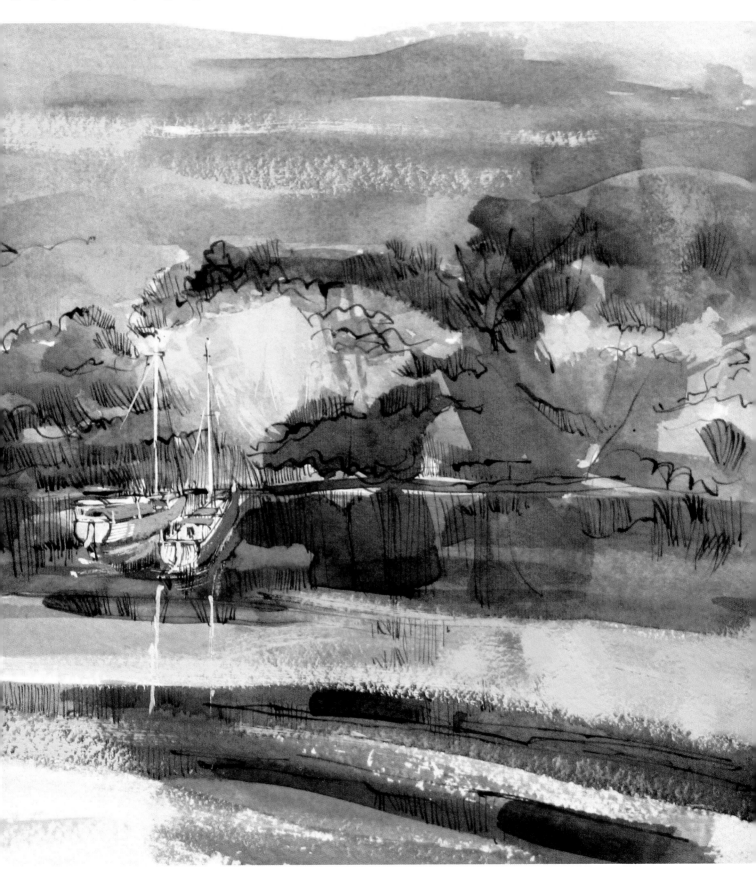

Cowlands Creek, watercolor, ink and gouache, 14 x 19½" (24 x 36cm)

Learning points

The challenges
- To use ink to hold a painting together.
- To achieve a glowing effect.

What you'll learn
- How to understate specifics.
- How to suggest boats.

Techniques you'll use
- Color washes.
- Dragging color.
- Adding body color.

The materials you'll need for this project

Support
140lb rough watercolor paper

Brushes
Large flat brushes
Rigger brush

Tools
Soft lead pencil
Ink nib pen

Colors
Nut-brown ink
India ink
White gouache

Artist's Quality Watercolors

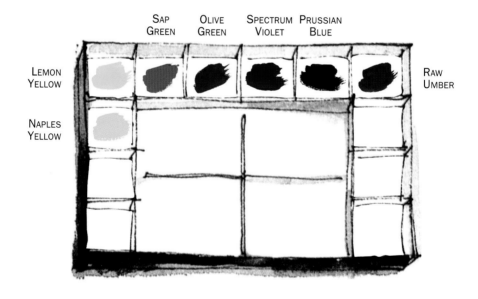

SAP GREEN OLIVE GREEN SPECTRUM VIOLET PRUSSIAN BLUE

LEMON YELLOW

NAPLES YELLOW

RAW UMBER

Step 1

Make a pencil sketch

Make a minimal drawing using a soft lead pencil. We will be rubbing the pencil outlines out once we've applied our pen lines, because we don't want too many conflicting lines destroying the effect.

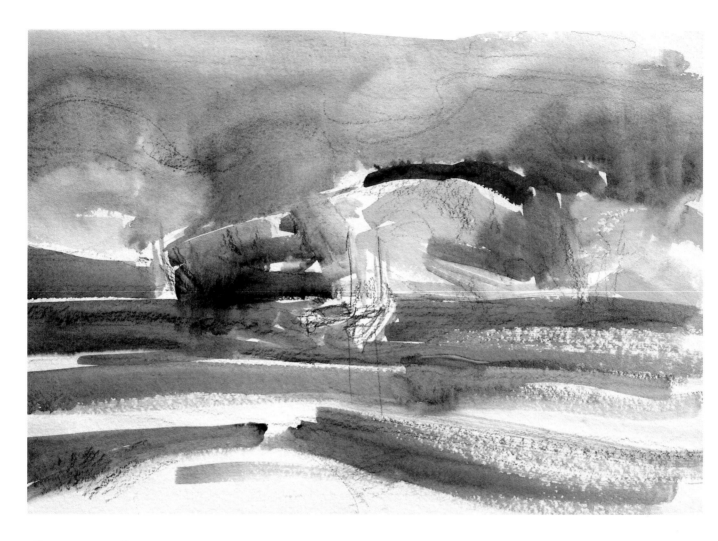

Step 2

Start with bright colors

As you can see, we will start by applying bright, "over the top", colors. Use a large flat brush to do this and don't worry too much about the accuracy of the placement. The result is an underpainting that has a certain glow. Use a fairly dry brush when applying the foreground strokes, so your brush skips over the rough surface of the paper, leaving areas of white paper that can be exploited as sunlight on water later on. Make sure you don't paint over the boats.

PRUSSIAN BLUE

SPECTRUM VIOLET

RAW UMBER

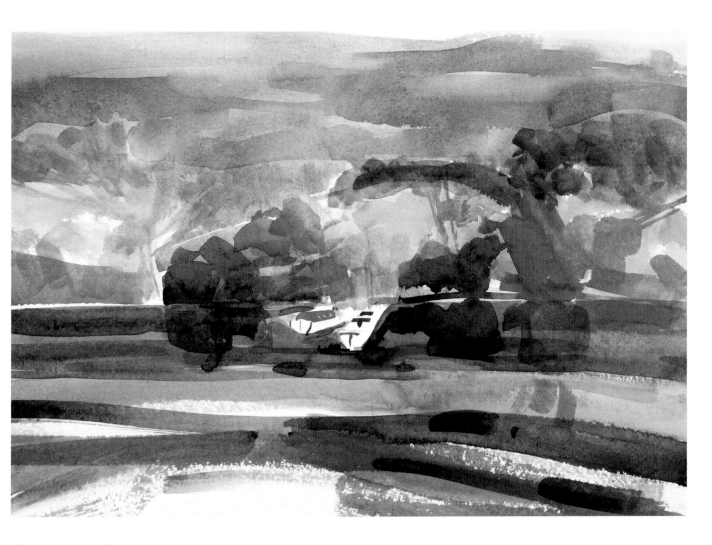

Step 3

Enhance the greens

There is still no detail to speak of, yet it is looking more real. I wanted to keep the background from jumping forward, so I made the creek go round a bend. Now tone down the blue with some transparent green washes. Use horizontal strokes for the water and cloud bands, and random shapes to describe the foliage. Reserve the white paper for the two boats and the white in the water.

NAPLES YELLOW

LEMON YELLOW

OLIVE GREEN

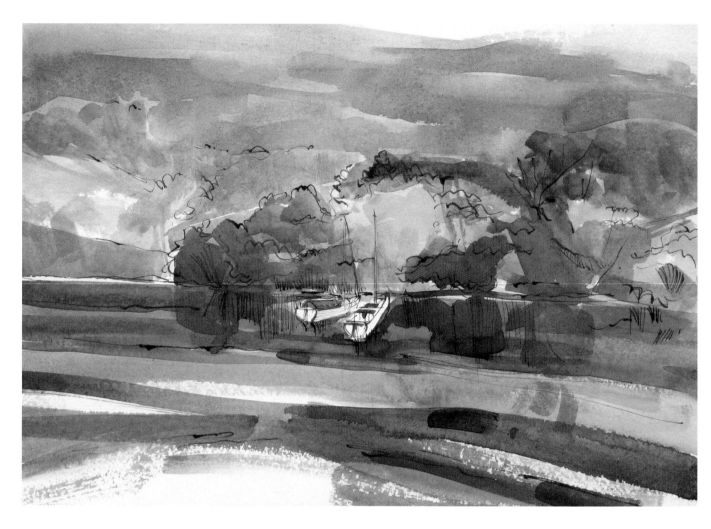

Step 4

Add ink lines

Once everything is dry you can start on the ink work. Do this sparingly — we don't want to turn our watercolor into an ink line drawing with color washes. In this case the ethereal effect is paramount. Use your rigger brush to describe lines on the hillside, top of the trees, some ripples in the water. Then use your ink pen to add a few uniform vertical lines to suggest reflections. Detail the boats and after practicing on a sheet of paper, add the masts and rigging confidently. Although these boats are not technically correct, the viewer immediately gets the idea. Gently rub out any pencil lines once the work is dry.

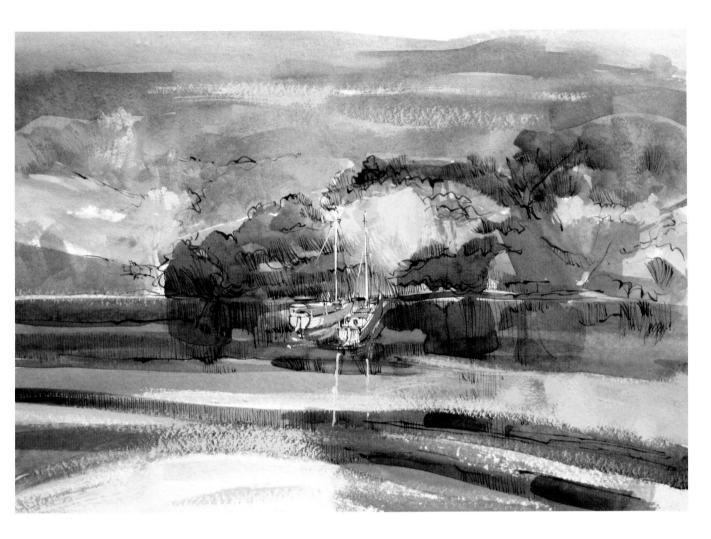

Step 5

Add white gouache for body

Now do some more ink work — vertical lines in the water and descriptive lines in the foliage. Then add body color by mixing some white gouache into Lemon Yellow, and drag this fairly dry consistency paint over the water. Look at that marvelous effect! Repeat this idea in the sky. Then lighten this color and introduce it into the foliage, particularly in the foliage round the focal point — the boats. Use straight white gouache to model the boats some more, and add pure white strokes to complete their masts, rigging topsides and hulls. Finish the boats by detailing with a pale Sap Green mix.

SAP GREEN

Introducing structure and strength with tone and line

I have painted this scene once or twice before. It is an old Cornish tin mine that goes out beneath the sea. There are no working mines left now and there are few remains more spectacular than this one. I was well back on the cliff face as I sketched because I am a little scared of precipices.

The mine buildings are on outcrops, with all the working parts out of sight. I heard stories that Queen Victoria was once lowered by cable from the right hand building to the left. I think her children undertook the task. The mine is a shell now but it does conjure up a past of which local Cornish people are extremely proud.

Certainly the painting was worth the effort, demanding a bold approach and strong colors. Fortunately it was a bright day. There were lots of considerations, one being the perilous situation itself — sheer drops and rough water — others being the splendor of the place and the birds. It was such a bright, sunny day, that I couldn't help but be impressed by the visual power of the place.

I painted in a sketchbook using limited gear. In view of the danger this is where pen and wash comes into its own. The scene called for a simple outline, washes of color with big brushes and ink to consolidate the detail. There is a little body color, but not much. In short, it may be simple, but I think it works very well.

Before you begin, read the entire project through so you know what's going to happen in each stage.

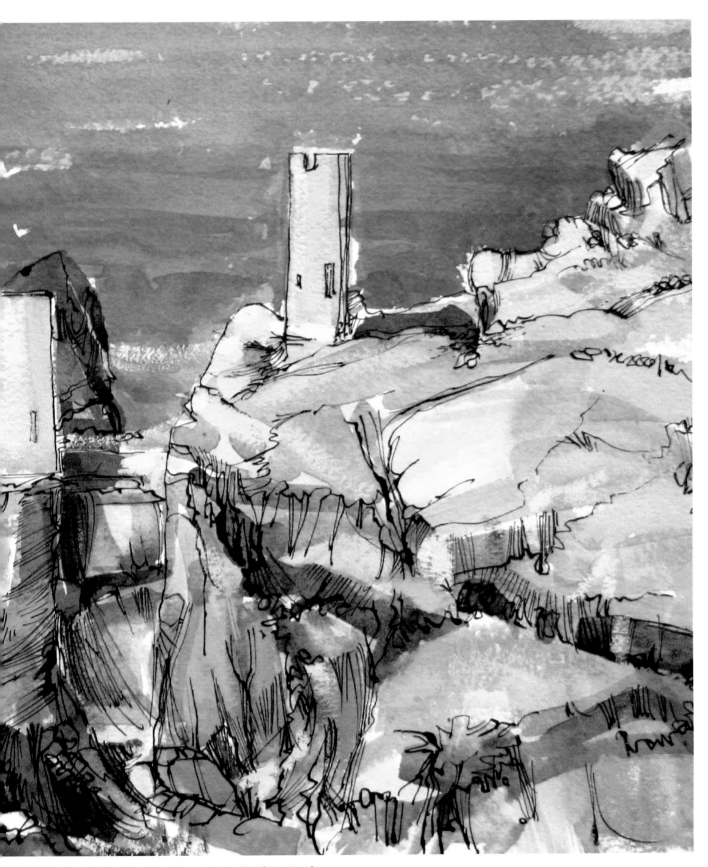

Crown Mine, Botallack, watercolor and ink, 14 x 19½" (24 x 36cm)

Learning points

The challenges
- To use a bold approach.
- To use strong colors.

What you'll learn
- How to tighten up a picture.
- How to introduce tone with ink.

Techniques you'll use
- Soft pencil sketching.
- Washes of transparent color.
- Drybrush.

The materials you'll need for this project

Support
140lb rough artist's quality watercolor paper

Drawing tools
Soft lead pencil
Ink pen

Ink
Black India ink

Body color
White gouache

Artist's Quality Watercolors

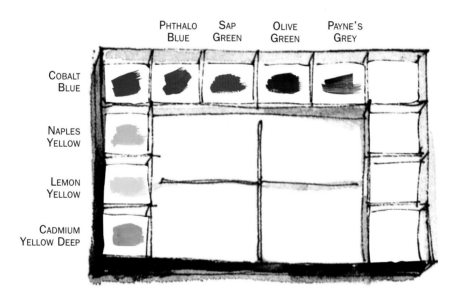

PHTHALO BLUE · SAP GREEN · OLIVE GREEN · PAYNE'S GREY

COBALT BLUE
NAPLES YELLOW
LEMON YELLOW
CADMIUM YELLOW DEEP

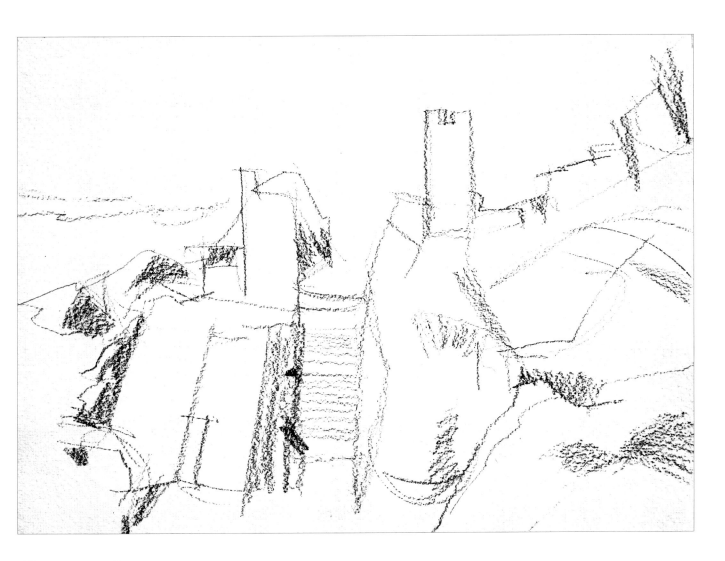

Step 1

Make your initial sketch in pencil

Make a rough sketch using a soft pencil. Later, we will rub these lines out.
Do make sure the rectangles constituting the mine buildings are straight,
and that proportions are correct. Notice that I indicated areas where tones
would be dark. We really want to preserve the chunky, angular, solid feel of
the place.

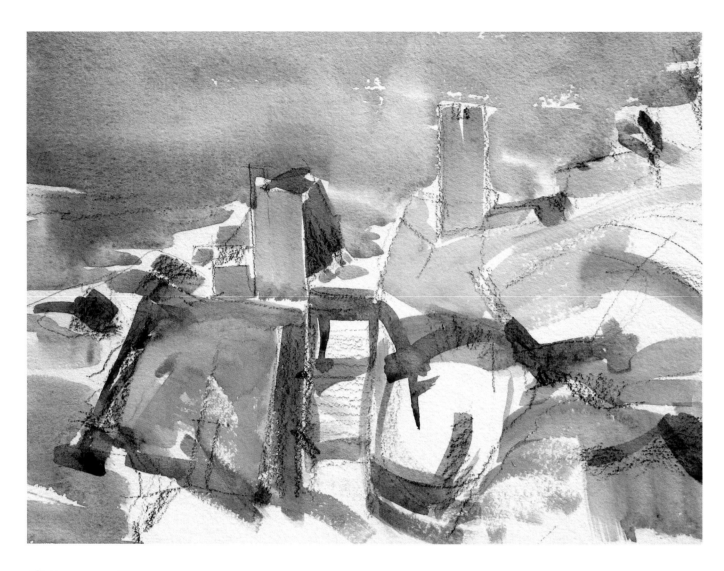

Step 2

Apply the first washes

Using your flat brush, quickly wash in the sea using Cobalt Blue, with some Phthalo Blue dropped in near the main tower. The goal at this stage is just to define the sea and land. Apply darker blue for the rocks and areas of dark shadow. Don't try to cover up all the white, these little highlights will help the painting look fresh and bright. Next, suggest grass, crevices and tone the buildings.

COBALT BLUE

PHTHALO BLUE

NAPLES YELLOW

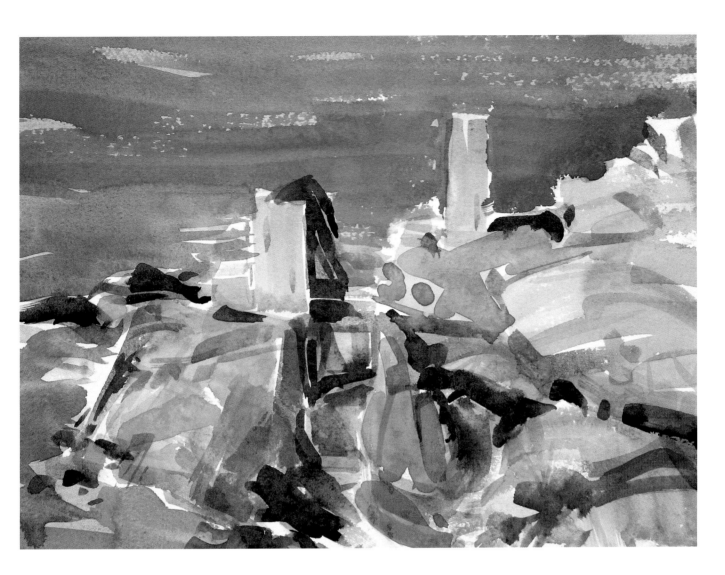

Step 3

Tighten up the drawing

Allow the painting to dry, then gently rub out the pencil lines. Now it's time to tighten up the drawing. I did this very quickly, after all, I thought I was going to be blown over the edge at any moment! The secret of overlaying washes (glazing) is to let the color beneath DRY before you apply the next, darker, color. Strengthen the sea, apply Payne's Gray to the rocks and shadow areas, but be careful to preserve the direction of the light on the crevice between the mine buildings on the left and the cliff on the right.

CADMIUM YELLOW DEEP

PAYNE'S GREY

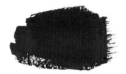

OLIVE GREEN

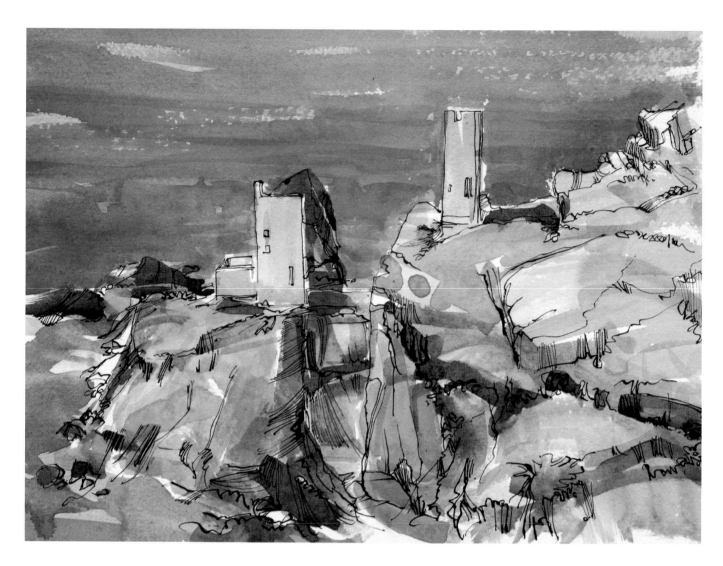

Step 4

Work on the main features

Now we are going to use our pen and ink to outline and emphasize major elements of the scene. Work loosely, but as much as you can, try to describe the form with the direction of your lines. Indicate windows on the buildings. Start indicating crags and boulders. Notice where I used continuous lines in the foreground. At this stage the painting looks a bit flat, but the next stage will resolve it.

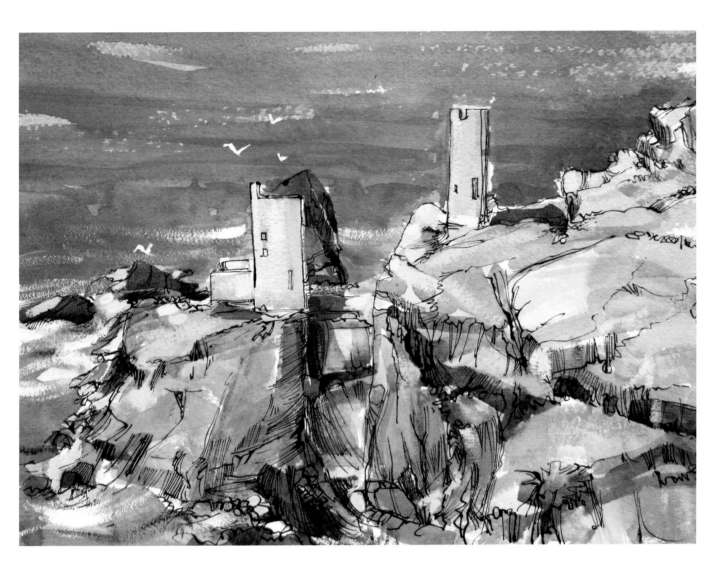

Step 5

Strengthen tone and add gouache

The differences in this stage are minimal but necessary. The separation
between the left hand rock and the one on the right should be
strengthened using Payne's Gray. Then apply more pen linework to further
describe rocks, crevices and shadow areas. Drag some white gouache
across the sea to create interesting highlights, and apply body color to
the rocks as well. Quickly indicate some gulls in white body color. (Practice
on some spare paper first.) Finally add color to the buildings and drag
some Cadmium Yellow Deep and White gouache across the foreground
using the dry brush technique to add texture.

PROJECT 9 ACRYLIC: *BEARE FARM, DEVON*

How dramatic diagonals reinforce this backlit scene

Some years ago I began a series of paintings of local farms. This one, Beare Farm, lay at the end of a lane, just before a railway line and a river. The hill behind it (which I later discovered to be an ancient volcanic sill with faults and quarries all over the place) is Posbury Clump. But that is another story.

After a preliminary sketch I set off to paint this morning scene. The sun was out, backlighting the farm and surrounding trees. I was above the farm, precariously perched on a slope called Heartbreak Hill.
It was so steep that I lashed myself to a conveniently placed telegraph pole to make sure I didn't roll down. All went well until I was hit by a swift, powerful rain squall. I couldn't see a thing and packed it in, but I did return to finish the job another day.

So this subject is interesting, geological and attractive — it also has history! I think the composition alone makes it a very suitable acrylic project.

Before you begin, read the entire project through so you know what's going to happen in each stage.

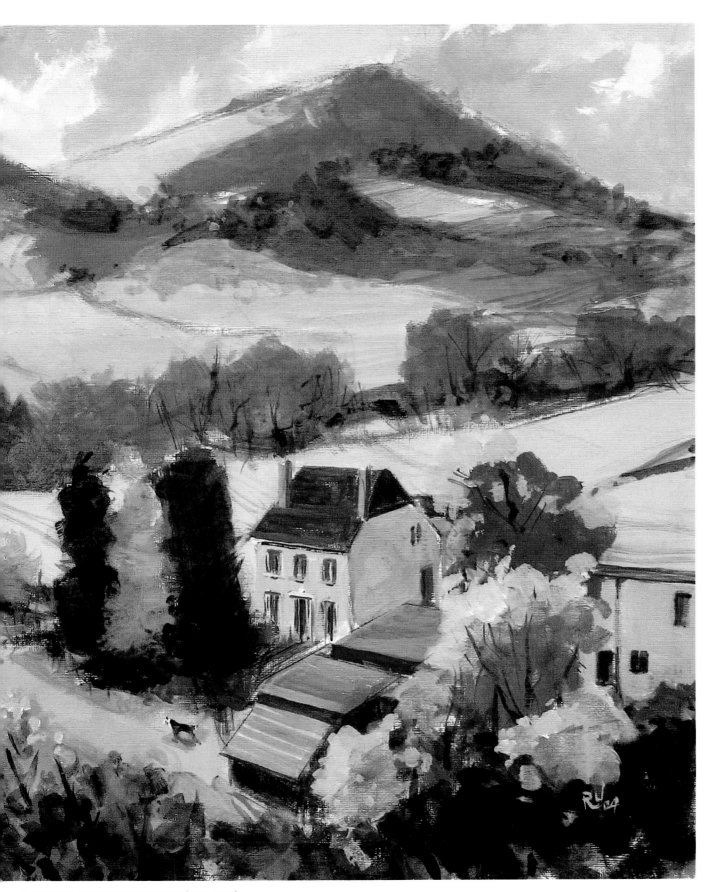

Beare Farm, Devon, acrylic, 15 x 19" (38 x 48cm)

Learning points

The challenges

- To "see" a scene through painting it.
- To paint backlit clouds.
- To paint natural clouds.

What you'll learn

- How to decide whether to proceed or amend.
- How to gauge perspective.

Techniques you'll use

- Graphite sketching.
- Fine detailing.

The materials you'll need for this project

Support
140lb canvas-textured acrylic paper

Brushes
1/2" flat sable/synthetic blend, a smaller flat, and a rigger

Drawing tool
Graphite pencil

Note: Remember to look after your acrylic brushes. Keep them rinsed and change the water regularly to retain clear colors.

Artist's Quality Acrylics

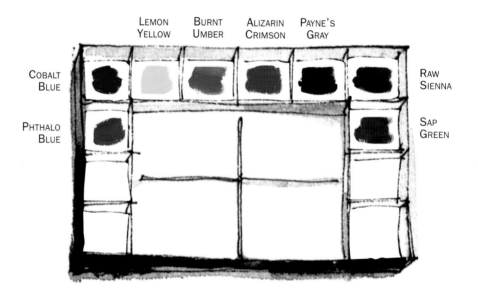

Acrylics are so very like gouache. The advantage is that, whilst both are opaque when dry, acrylics will not come off when you brush over them with new paint. The dry brush effect I so often use (thick paint brushed so that only the raised texture of the paper accepts it) can be even more effective and is certainly less likely to smudge.

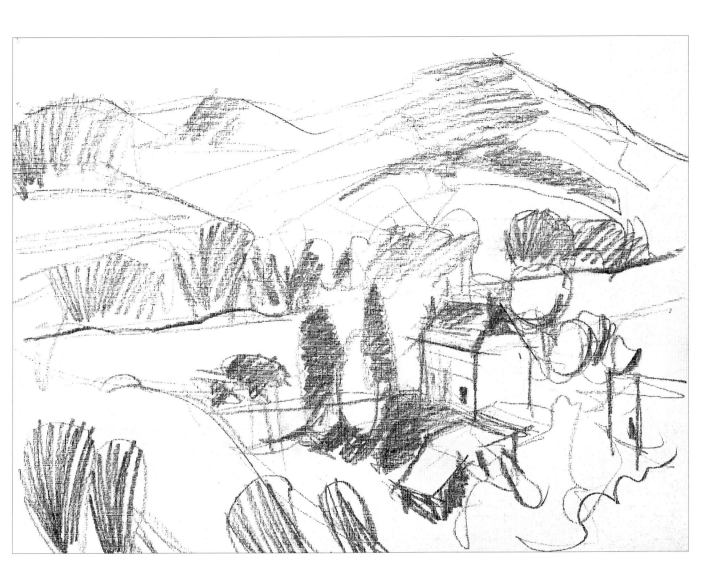

Step 1

Outline key elements in pencil

This is a fairly complex scene, so we will make it easier by making a graphite pencil outline to establish the various important elements in the design. Place the background hills, middle-distance river course and the foreground trees and buildings. Indicate the shadow and tonal plan right at the beginning.

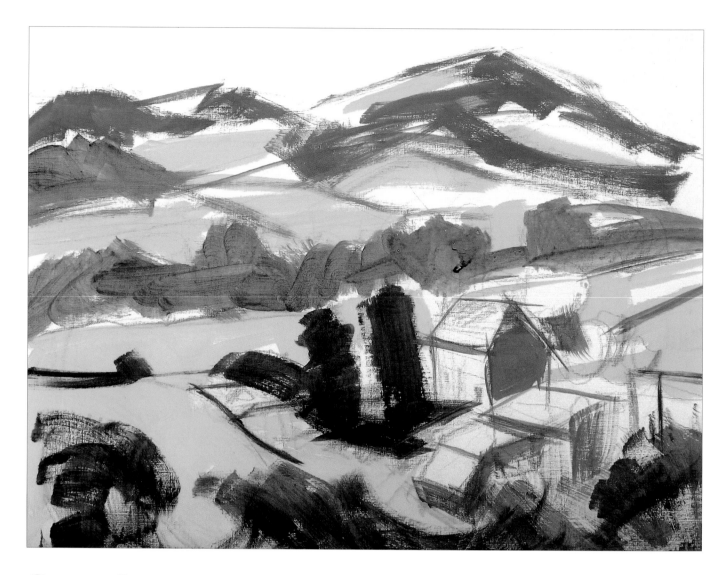

Step 2

Block in the lights and darks

The picture is primarily backlit so the intensity of the light and color is vital. In this stage define what is lit and what is in shadow. Don't worry about detail at this stage. Use Lemon Yellow on the fields, Sap Green for the foliage and trees along the watercourse, and Cobalt Blue mixed with white for the shadows on the distant hills and buildings. Create a dark mix of Cobalt Blue and Sap Green for the main tall trees and foreground foliage.

There is a dramatic diagonal sweep across the work which places the farm buildings in an important place. Yes, the color is rather vivid right now, but we will tone this down later. It's always better and easier to tone down rather than try to tone up.

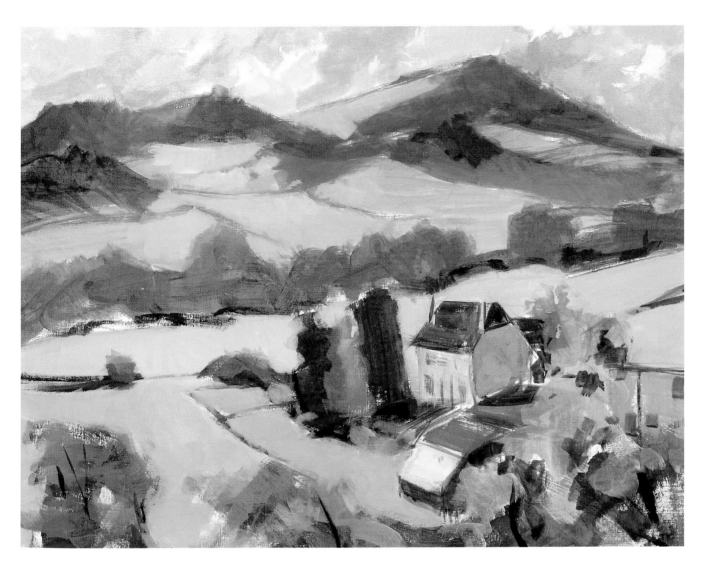

Step 3

Draw in specifics

The dramatic left to right sweep gives the painting movement, so we must retain this feel. Paint in the sky, and angle the clouds so they support this movement. Leaving white on the clouds reinforces the backlit effect. A second diagonal is formed by the building group, with its tall trees. Being able to see design possibilities when scouting for subjects is part of the skill in being an artist. If such elements are not present — you can always add them. A successful work demands good composition.

Start painting the specifics — the hill shadows; strengthen the river course, adding tone; indicate the third tree; work on the farm buildings and grey off the foreground foliage. Mix some Sap Green with Lemon Yellow and tone down the fields. Notice that the darkest darks are in the focal area.

LEMON YELLOW

SAP GREEN

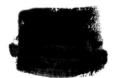

PAYNE'S GRAY

ALIZARIN CRIMSON

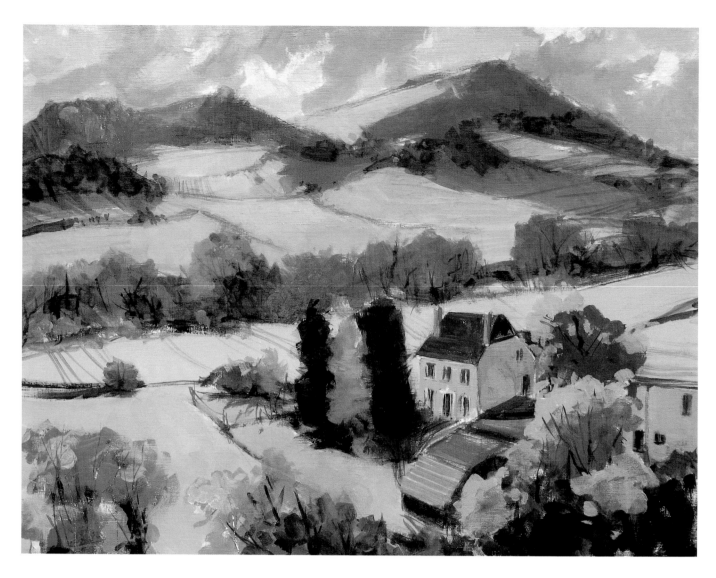

Step 4

Tone down some more

First strengthen the blue in the sky, but maintain the backlit effect and wispy edges. Then gray off the hillside shadows and tone down the fields even more. Add some calligraphic directional lines for interest.

Add autumn foliage colors along the river course, and then use your rigger brush to confidently apply tree branches and trunks. Detail the clumps of brushes, then work on the three main trees, preserving the darks. The buildings are next, painted in harmonious colors for unity and to preserve the important v-shaped design element.

Detail the foreground foliage, and introduce stronger darks to reinforce the presence of the foreground. We've maintained the sunlit feel, but in the next step we make some important changes.

BURNT UMBER

RAW SIENNA

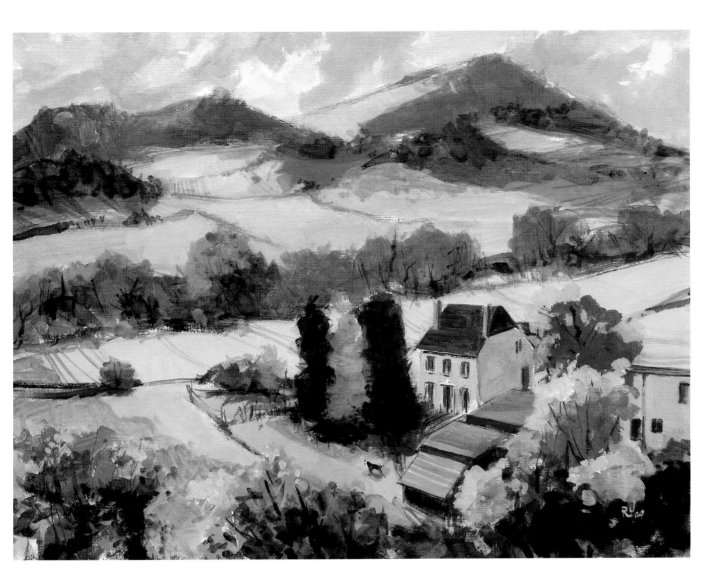

Step 5

Adjust and finish off

After taking time to evaluate the painting obvious changes need to be made to the buildings. We will paint over the shadow on the farthest roof shed and correct the angle on the foreground roof. Detail the main house, window and doors. Then work over the hills and paddocks rounding off shadows and introducing shadows into the left foreground. This helps focus the eye in the important area.

Strengthen the darks in the foreground, and then add a dog!

Mastering thin glazes overlaid with bold, thick paint

This subject was featured in International Artist magazine (April/May 2004) as an oil pastel, but I thought it would be a good one for an acrylic project.

Frenchman's Creek was the title of Daphne du Maurier's romantic book, and is every bit as mysterious as she described. Like all Helford River creeks, it is tidal; the challenge is to catch it when there is enough water and sunlight to make it look interesting.

On this bright morning the tide was coming in. I walked all round the creek to find the best viewpoint and decided to look up the creek, into the shadows. The fallen branch added to the drama. The effects of sun and water, foreground silhouettes and tree reflections, provide opportunities to practice our acrylic technique — thin glazes and bold, thick paint.

The intention is to keep the picture simple, with a strong design and bold application of paint. It should also look brighter because acrylics have a tendency to accentuate color values.

Before you begin, read the entire project through so you know what's going to happen in each stage.

Frenchman's Creek, Helford River, Cornwall, acrylic, 15 x 19" (38 x 48cm)

Learning points

The challenges

- To convey mystery through bold colors.
- To use strong design for a simple picture.
- To use only essential details.

What you'll learn

- How to accentuate color values.
- How to dilute paint for washes and glazes.
- How to use flow enhancers.

Techniques you'll use

- Direction line drawing.
- Washing.
- Glazing.
- Scratching lines.
- Overpainting.

The materials you'll need for this project

Support
140lb canvas-textured paper

Brushes
Rounds and flats, and a rigger. Painting knife.

Body color
White gouache

Note: Remember to look after your acrylic brushes. Keep them rinsed and change the water regularly to retain clear colors.

Artist's Quality Acrylics

Most acrylic paints come in thin or thick consistency. To achieve the painterly feel of this project, we will be using thick paint. To create watery washes and glazes with this paint, simply dilute it with water, or one of the flow enhancer acrylic mediums available.

Thinner paint tends to have a bubbly consistency that can be quite pleasant. When it dries the result is a grainy effect.

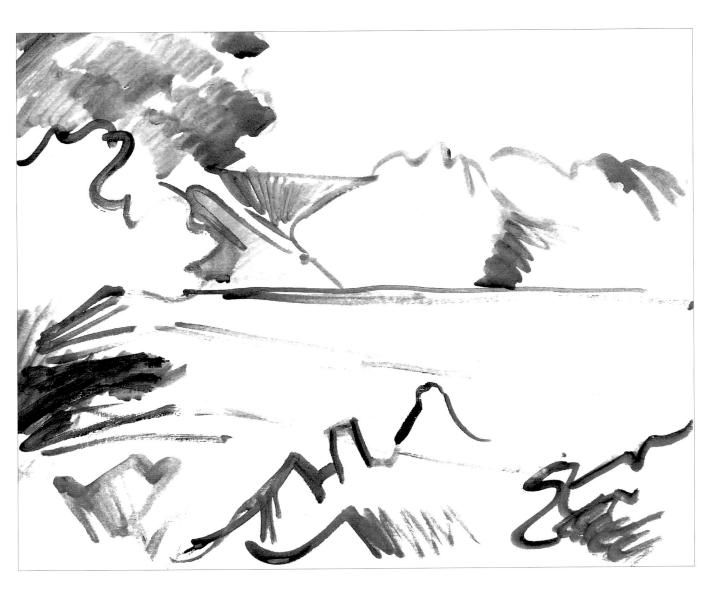

Step 1

Draw the main lines

At this point there is no reason to go into great detail. Merely draw the main direction lines and large color areas in Sap Green using a round brush. Later we will wash in color areas and increase tonal contrasts.

SAP GREEN

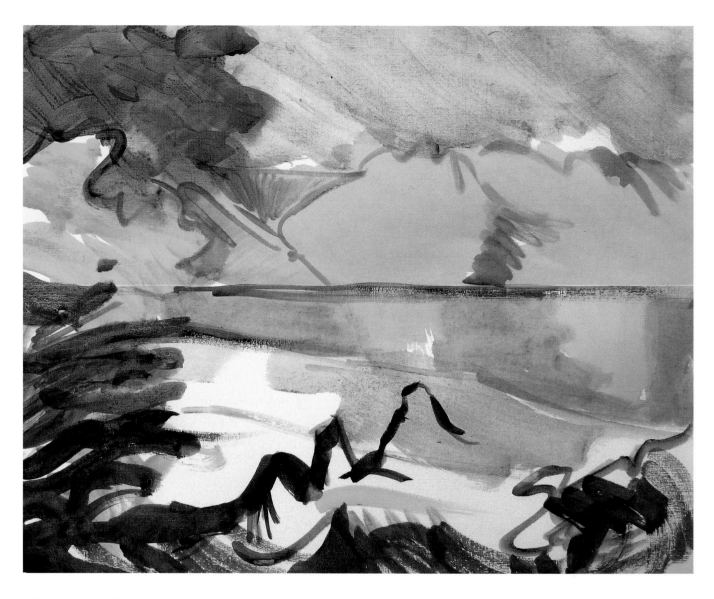

Step 2

Add color

Working from the top add Lemon Yellow and Cadmium Yellow Deep to the foliage on the left. Paint the sky and river, being careful to preserve the area of white paper earmarked for the main light reflections. Add a swoosh of this color in the foreground. Dilute Sap Green and add a touch of Lemon Yellow to wash the hills and reflections.

Now, add Light Red and stroke in an Alizarin Crimson and touch of Black mix for the foreground. Take care when structuring the fallen branch, since it is a main feature of this scene.

LEMON YELLOW

CADMIUM
YELLOW DEEP

ALIZARIN CRIMSON

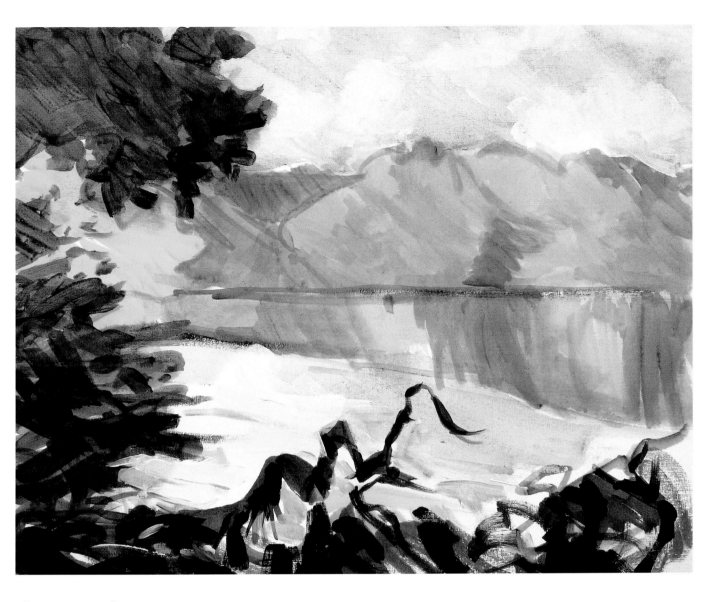

Step 3

Increase balance of light to dark

Now the balance of light to dark is closer and the shapes of trees are becoming more obvious. Apply the paint as you would for any other medium: light washes, increasing the volume and strength as you establish these features.

Darkening the top foliage and strengthening the foreground darks sets the dark/light tonal balance and helps suggest distance by separating the foreground from the middleground and background.

Next, model some clouds with Cobalt Blue tinted with white gouache. Then apply more green to the hills and drop in some Lemon Yellow. Repeat these colors in the water.

COBALT BLUE

SAP GREEN

LEMON YELLOW

Step 4

Overpaint the sky and trees

In this step overpaint the trees and the sky above. There are areas of finished detail in the top half. Looks good so far.

First apply pure white gouache mixed with a little Lemon Yellow and give form to the clouds. Then start overpainting the trees on the further bank. Vary your greens and add some darker areas to give tonal contrast.

Remember to do the reflections too. Introduce some Light Red. Add more blue to the water, and introduce some horizontal strokes of a pale green. Then take pure Cobalt Blue and dab this right across the foreground.

Despite the fact that acrylics dry so quickly, there are area places where we let one wet color brush into the next, rather like oil painting. If the paint is quite thick, it won't run but could turn muddy, so watch it!

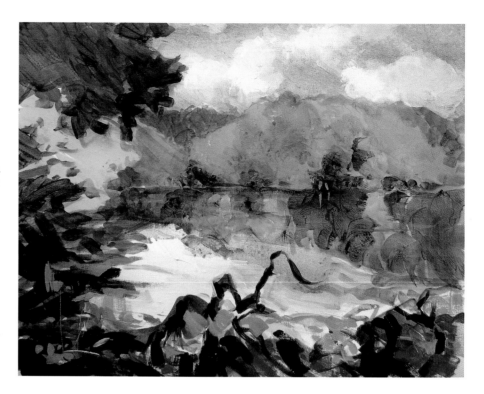

HINT:

Acrylic instruction books tell you many tricks, one of which is to scratch lines of detail, leaving white paper. If you want to do this, remember that if you scratch the top wet layer you will expose what is underneath. If you have already painted a dark color underneath, your scratch will not expose white. I have caught myself out on many occasions.

Step 5

Intensify and add more color

Really model that overhanging tree with Cerulean Blue and Sap Green and add Black. Use your smaller brush to indicate individual leaves. Then use mixes of Cadmium Yellow Deep and Light Red, Lemon Yellow and White and Cadmium Deep and White to the autumnal bush beneath as a rest from all those greens. The overall effect is one of depth. But it's always good to stop and take time out to examine the painting to see what might be improved.

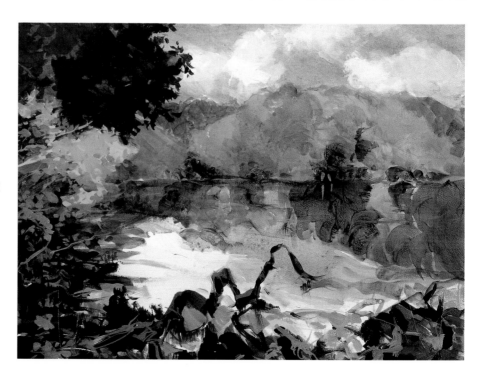

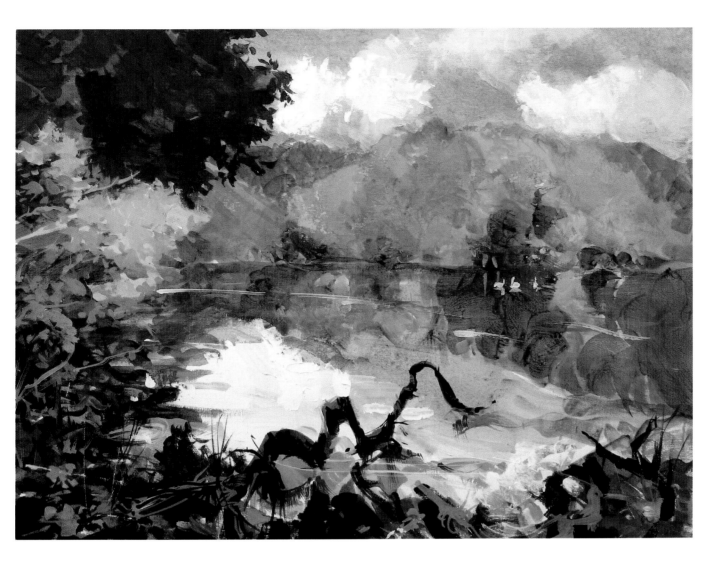

Step 6

Modify, tidy up and finish

Then tidy up and emphasize by applying paint with a rigger and a painting knife. The rigger enables you to draw in some essential (but not too much!) detail. The painting knife adds panache (or destroys it altogether!). Modify the dark foliage. Add more pure white gouache to the sky, and while you have that on your brush, add white to the water, suggest ripples and introduce the water birds. Use the rigger to add calligraphic strokes for details in the foreground and scratch out some interesting grasses. Some Cadmium Yellow Deep dry brush work in the background foliage completes the painting. Compared to my original attempt at this subject, which in oil/oil pastel took nearly a week, I think this picture, which took one day, is just as effective.

CADMIUM YELLOW DEEP

BLACK

LEARNING POINTS

✓ Design

Without a good design you can't create a good painting, no matter how well you have mastered the techniques. Before you put pigment to paper, take time to plan.

- Define your center of interest — the area of the painting with the most detail and the most contrast.
- Evaluate possible eye-paths to lead your viewer into and around your painting.
- Plan the values in your painting to strengthen the eye-path and center of interest.

Even when you can't wait to get painting, take a few minutes to plan. It's well worth the investment.

✓ Glazes (layers)

Layering — or glazing — is the application of additional washes of color over dry paint. Glaze when you need to

- intensify color or value,
- change or create a color,
- combine colors that would turn into mud if mixed on your palette.

✓ Shadows

A good design incorporates dramatic shadows. Shadows lead the eye to the center of interest and provide the contrast that makes a painting interesting. When painting shadows, remember to

- establish a consistent light source,
- use cooler colors when you want the shadows to recede, and
- include colors in your shadows.

If you're painting outdoors or are using field sketches, make sure to take into account those constantly moving shadows. It's best to take backup photos to capture light and shadow patterns.

✓ Primary colors

Have you ever wanted to mix a special color, but had no idea how? Understanding how your pigments interact makes it easier to mix the colors you want. Start with just the primaries to learn what your pigments can do.

- Create a simplified palette from six colors — the warm primaries and the cool primaries.
- Learn which of your pigments are biased toward warm and cool colors.

✓ Color temperatures

Each color on the color wheel is considered either warm or cool. You can use color temperature in combination with value to give your painting depth. Watercolor pigments, however, are never pure colors from the color wheel. Learn the color bias of your pigments so you can more effectively give your two-dimensional painting a three-dimensional look.

- Warm colors — red, yellow, orange — seem to come forward in a painting.
- Cool colors — blue, violet, some greens — seem to recede.
- Individual pigments, themselves primarily either warm or cool, may also contain a secondary warm or cool component.

✓ Complementary colors

One of the most dramatic of color schemes is the complementary color scheme. Complementary colors, when used together, have unique properties that can add interest to your painting and utility to your palette.

- Create interest and "vibration" by placing complementary colors next to each other.
- Complementary colors also brighten each other when placed side by side.
- Gray down a color by adding its complement.

✓ Value contrast

Value is the lightness or darkness of a color. Your paintings will have more depth if you use the full range of values.

- Squint at your painting to reduce it down to its basic values.
- A value scale can help you incorporate the full range of values in your painting.
- Although you don't have to use every value on a value scale, use at least a light, a medium and a dark.

✓ Learning from mistakes

The most important thing you need to remember is: Don't be afraid of making a mistake. Most of them are fixable.

ABOUT THE ARTIST

During a highly creative career that began in childhood and is stronger than ever in his later years, Robert Jennings has explored the attributes of many mediums. He has worked with watercolor and gouache, pen and wash, oil and oil pastel, and, more recently, acrylics — with many in-between. He has also traveled extensively, both for pleasure and through his work in the advertising industry, painting whenever and wherever possible.

Robert Jennings likes to create projects that push his knowledge into interesting creative directions, sometimes for the subject itself or simply for the challenge such work engenders. Six years ago he began to paint geological features of the southwest of England, from the brilliantly coloured striated rocks of West Somerset to the elaborately folded strata of Devon, to say nothing of the granite masses of Dartmoor and Exmoor. These shapes proved to be dramatic in a way he could not have imagined, and a never-ending source of inspiration. This scheme evolved into a study of the rivers of Devon and Somerset, from infant streams to wide estuaries.

Neither a fisherman nor an expert on rivers, Robert early on showed an angler various paintings to see what he thought of them. When the angler said, of a painting of the River Teign, "I caught a trout behind that rock," Jennings knew he was on the right track, and he proceeded to paint not only other Westcountry rivers in England but also the Yangste in China, the Ganges in India, and the Nile in Egypt — as well as pack ice in Greenland. Referring to his world travels he says, 'There are so many things to paint out there.'

Robert Jennings' paintings have been featured in International Artist magazine (April/May 2004 and August/Sept. 2004). He lives in Devon, England.

What artists want!

If you liked this book you'll love these other titles written specially for you.

Artist's Projects You Can Paint

Each of the 10 thrilling step-by-step projects in these books gives you a list of materials needed, and initial drawing so you can get started straightaway. Dozens of individual color swatches will show you how to achieve each special mix. Clear captions for every stage in the painting process make each project a fun-filled painting adventure.

- **10 Artist's Projects
 FLORAL WATERCOLORS**
 By Kathy Dunham
 ISBN: 1-929834-50-0
 Publication date: August 04

- **10 Artist's Projects
 FAVORITE SUBJECTS IN
 WATERCOLORS**
 By Barbara Jeffery Clay
 ISBN: 1-929834-51-9
 Publication date: October 04

- **10 Artist's Projects
 WATERCOLOR TABLESCAPES
 LOOSE & LIGHT**
 By Barbara Maiser
 Publication date: Spring 2005

- **10 Artist's Projects
 EXPERIMENTS WITH
 IMPRESSIONISM EN PLEIN AIR**
 By Betty J. Billups
 Publication date: Spring 2005

- **10 Artist's Projects
 SECRET GARDENS
 IN WATERCOLOR**
 By Betty Ganley
 Publication date: Spring 2005

Art Maps

Use the 15 Art Maps in each book to get you started now!

Art Maps take the guesswork out of getting the initial drawing right. There's a color and materials list and plenty of tit-bits of supporting information on the classic principles of art so you get a real art lesson with each project.

- **15 Art Maps
 HOW TO PAINT WATERCOLORS
 THAT SHINE!**
 By William C. Wright
 ISBN: 1-929834-47-0
 Publication date: November 04

- **15 Art Maps
 HOW TO PAINT WATERCOLORS
 FILLED WITH BRIGHT COLOR**
 By Dona Abbott
 ISBN: 1-929834-48-9
 Publication date: October 04

- **15 Art Maps
 HOW TO PAINT EXPRESSIVE
 LANDSCAPES IN ACRYLIC**
 By Jerry Smith
 ISBN: 1-929834-49-7
 Publication date: December 04

How Did You Paint That?

Take the cure for stale painting with 100 inspirational paintings in each theme-based book. Each artist tells how they painted all these different subjects. 100 fascinating insights in every book will give you new motivation and ideas and open your eyes to the variety of styles and effects possible in all mediums.

- **100 ways to paint
 STILL LIFE & FLORALS**
 VOLUME 1
 ISBN: 1-929834-39-x
 Publication date: February 04

- **100 ways to paint
 PEOPLE & FIGURES**
 VOLUME 1
 ISBN: 1-929834-40-3
 Publication date: April 04

- **100 ways to paint
 LANDSCAPES**
 VOLUME 1
 ISBN: 1-929834-41-1
 Publication date: June 04

- **100 ways to paint
 FLOWERS & GARDENS**
 VOLUME 1
 ISBN: 1-929834-44-6
 Publication date: August 04

- **100 ways to paint
 SEASCAPES, RIVERS & LAKES**
 VOLUME 1
 ISBN: 1-929834-45-4
 Publication date: October 04

- **100 ways to paint
 FAVORITE SUBJECTS**
 VOLUME 1
 ISBN: 1-929834-46-2
 Publication date: December 04

How to order these books

These titles are available through major art stores and leading bookstores.

Distributed to the trade and art markets in North America by

F&W Publications, Inc.,
4700 East Galbraith Road
Cincinnati, Ohio, 45236
(800) 289-0963

Or visit: www.artinthemaking.com